GRAND CANYON

WINDOW OF TIME

by
STEWART AITCHISON

SIERRA PRESS
MARIPOSA, CA

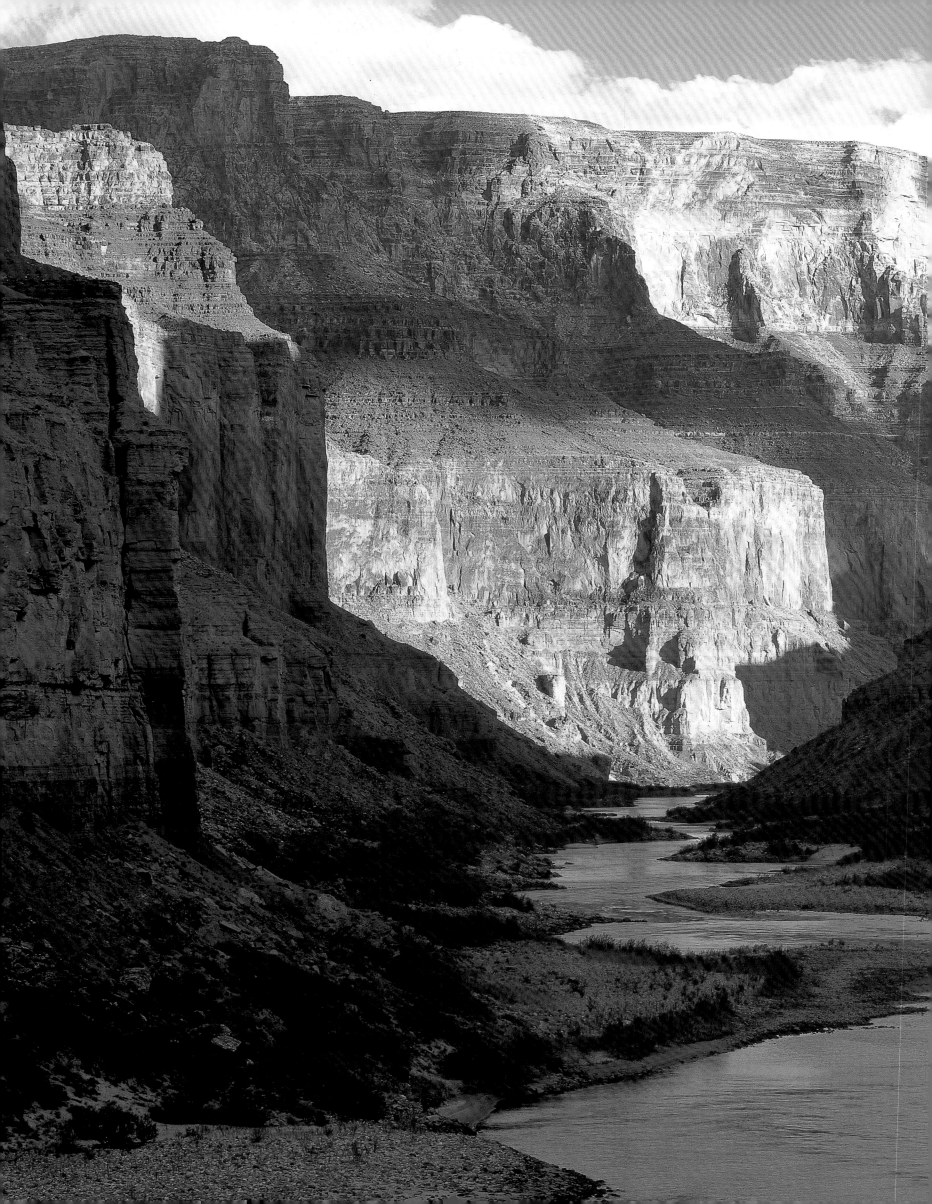

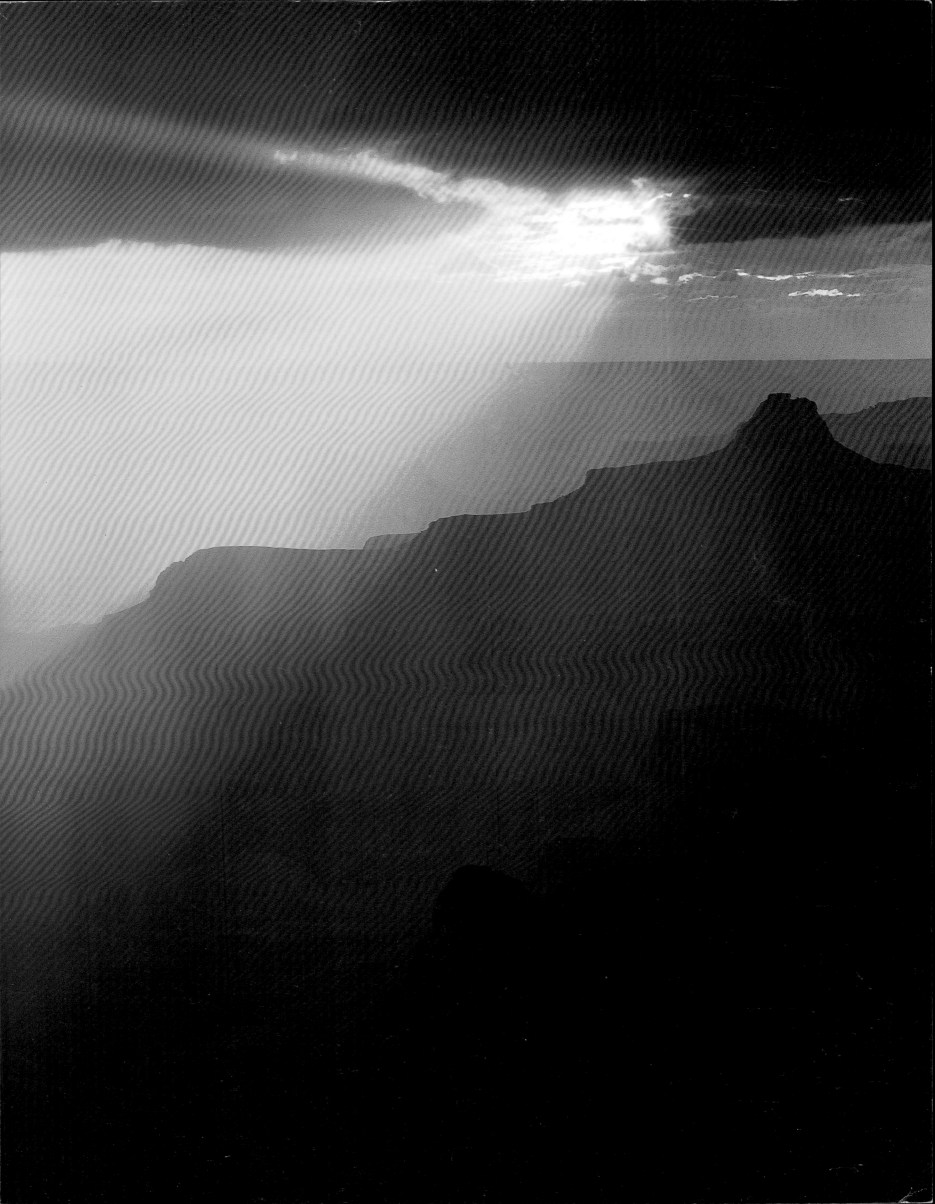

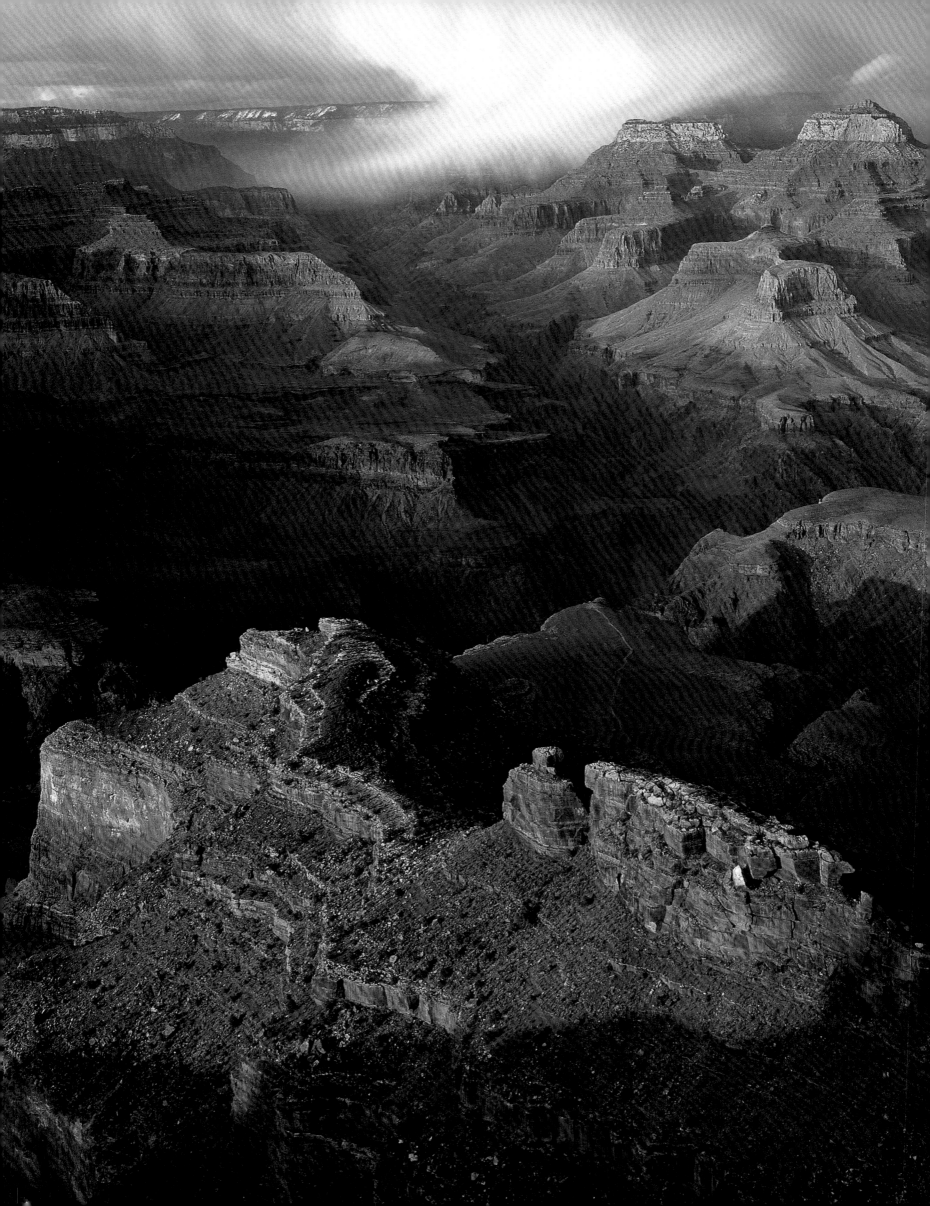

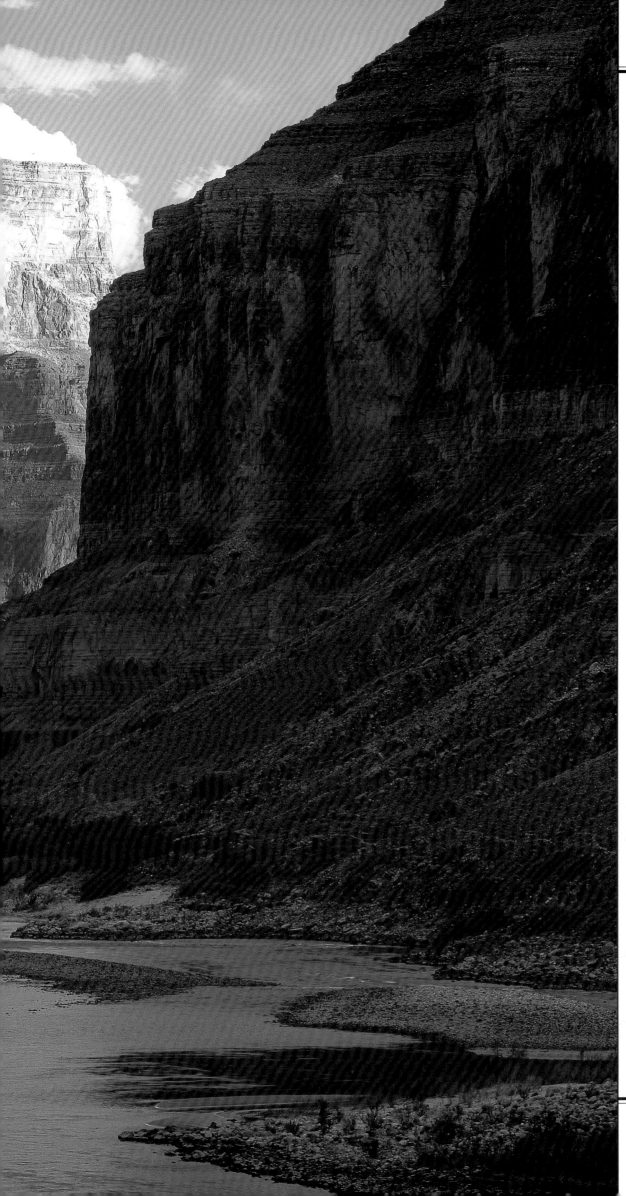

TABLE OF CONTENTS

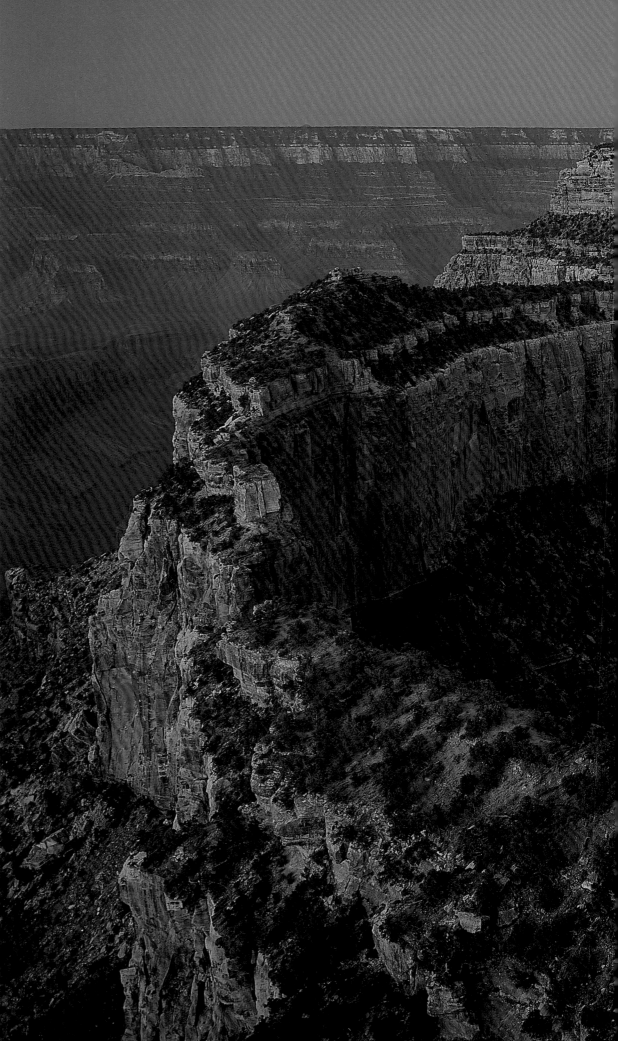

DEDICATION:
To Ann & Kate—S.A.

ACKNOWLEDGMENTS:
Thanks to Jeff Nicholas, Laura Bucknall, and the Sierra Press staff for suggesting and organizing this project. I greatly appreciate Rose Houk's fine editing, Ellis Richard's checking of facts, all the friends who kindly reviewed the manuscript, and Late for the Train for providing caffeine support. Any remaining errors are strictly my own. —S.A.

FRONT COVER:
The warm glow of sunset, Yavapai Point, South Rim. PHOTO © DICK DIETRICH.

INSIDE FRONT COVER:
Rain showers illuminated at sunset, Cape Royal, North Rim. PHOTO © JACK DYKINGA.

TITLE PAGE:
Clearing storm, late afternoon, Hopi Point, South Rim. PHOTO © LARRY ULRICH.

PAGE 4/5:
Cliffs of Marble Canyon dwarf the Colorado River near Nankoweap Canyon. PHOTO © LARRY ULRICH.

PAGE 5:
Agave and pinyon pine cone. PHOTO © JACK DYKINGA.

THIS PAGE (RIGHT):
Moonset over Wotans Throne, dawn, North Rim. PHOTO © TOM BEAN.

THIS PAGE (BELOW):
Prehistoric pictographs. PHOTO © STEWART AITCHISON

PAGE 8/9:
Mt. Hayden and ridges seen from Point Imperial, sunset, North Rim. PHOTO © CHARLES CRAMER.

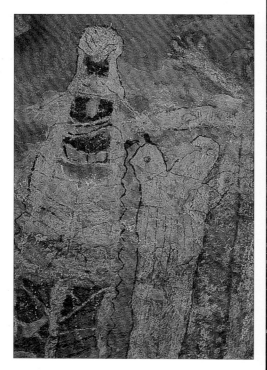

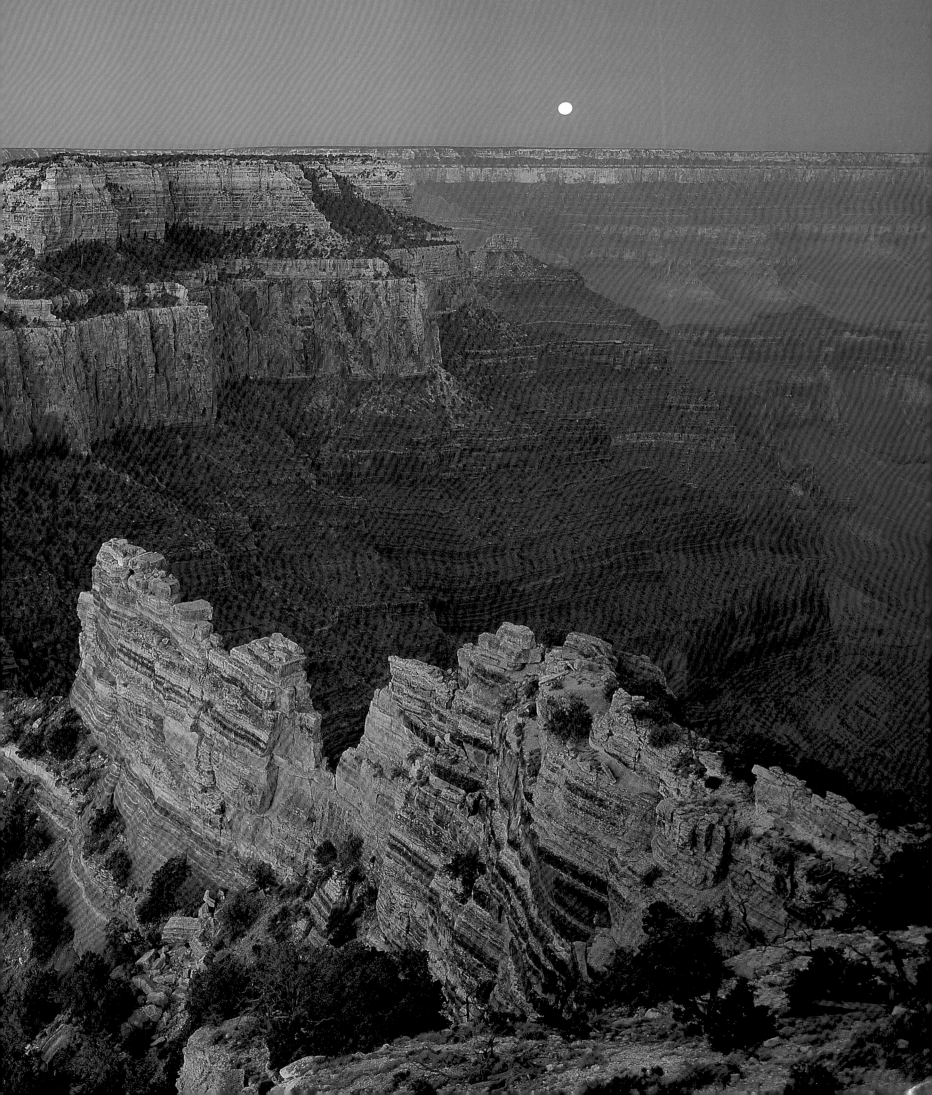

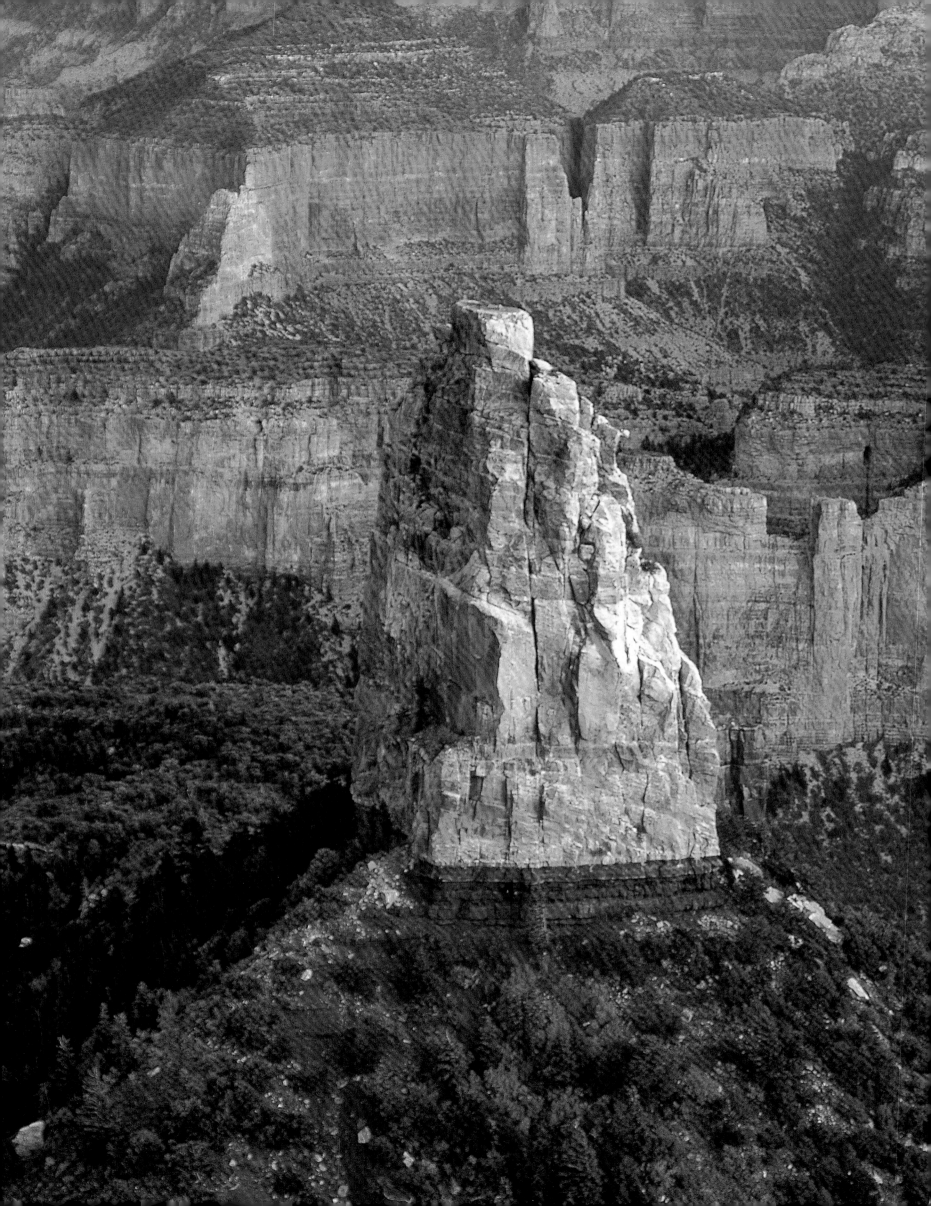

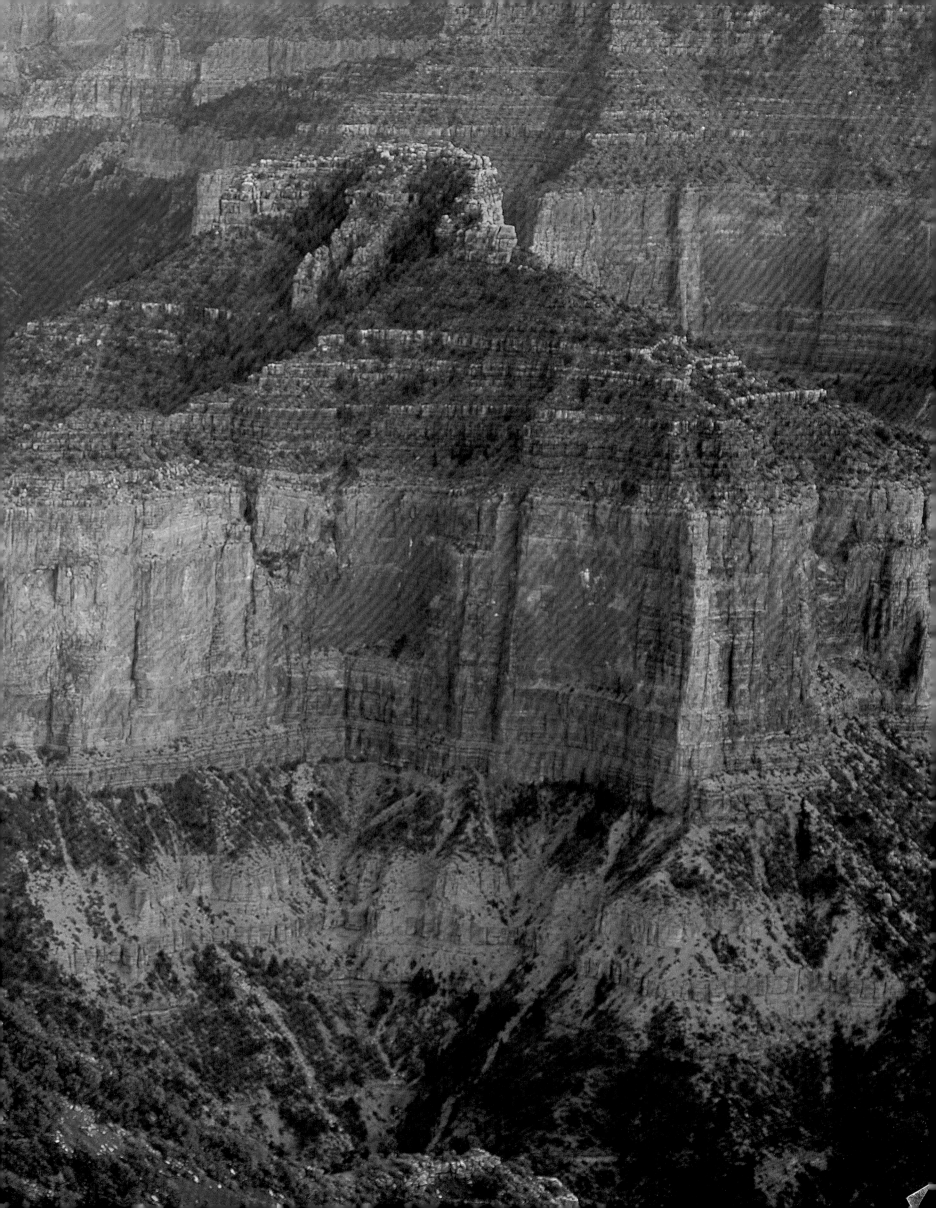

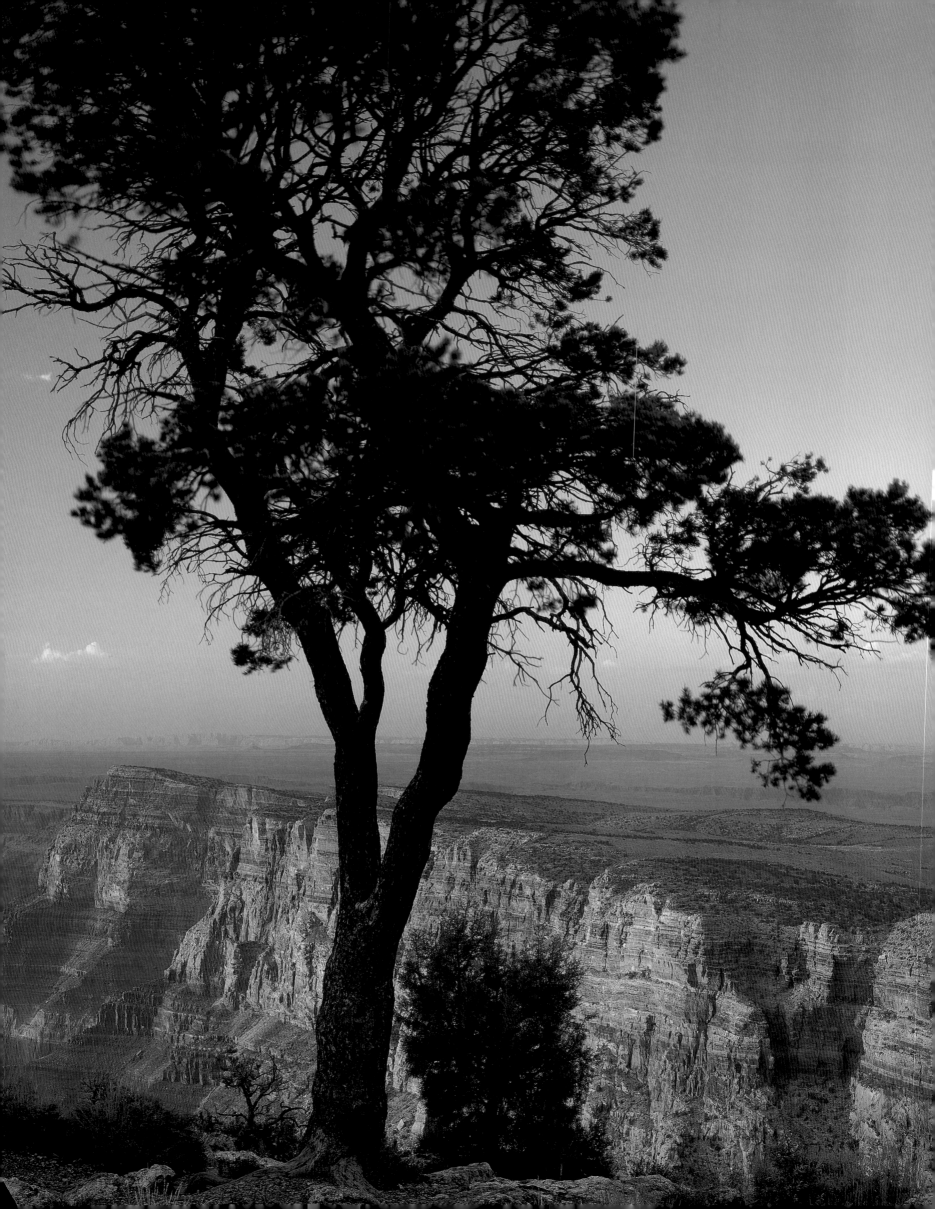

The GRAND CANYON:

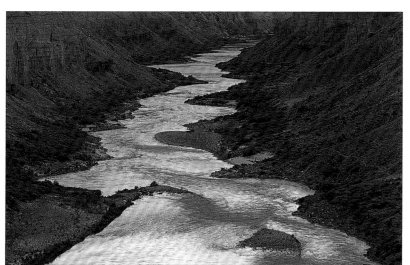

Colorado River below Nankoweap Creek.　　PHOTO © CHRISTOPHER BROWN

The steam whistle pierced the azure sky. I swayed gently in my seat as the train headed north. We were traveling at a civilized speed—fast enough to know that it would only take another hour to reach the Grand Canyon but slow enough to enjoy the scenery. Not far from the Williams station, the tracks left extinct volcanoes and cinder cones behind and descended slightly onto a saltbush and rabbitbrush plain. I glimpsed a small herd of pronghorn and then a couple of cowboys chasing skinny cattle. Soon we were passing into a pygmy woodland of junipers and pinyon pines carpeted with sagebrush. An old Santa Fe Railroad promotional brochure labeled this the Black Forest. But still no sign of the Grand Canyon.

As the grade steepened, the train slowed almost to a walk. Tall ponderosa pines replaced the diminutive woodland. A mule deer doe and fawn bounded into the forest. We passed a cabin where two small children and a fuzzy dog gave us notice. The tracks curved to the right and nearly doubled back on themselves. The train came to a halt, and then backed up onto another section of track. We had done a Y-turn to back into the old Santa Fe Railway Station, built in 1909, one of only three log train stations remaining in the United States. But where was the much heralded Grand Canyon?

I disembarked, walked past the station, and followed the walk up the hill. There stood the glorious El Tovar Hotel, built to rival the great resort hotels of Europe. Across from the hotel, to my right, was the unpretentious Hopi House, a replica of the centuries-old village of Oraibi. It could easily be the turn of the last century rather than the eve of the next, but people's clothing and the vehicles were of the wrong vintage. My footsteps carried me beyond the historic buildings, and suddenly I found myself standing on the edge of the grandest of all canyons.

I was on the rim of the world. Nothing but space and raw rock before me. Golden-tan cliffs dropped to a crimson slope that led to vermilion ledges and more bluffs. Below was another vertical wall of a rosy hue, in places carved into deep alcoves. This precipice was followed by another incline, long, greenish-gray, and gently leveling off into a broad bench. The bench led to the brink of a dark, foreboding inner gorge, a prison hiding the Colorado River.

At first it seemed like a lifeless void, home only to the wind and the glare of the noontime sun. But then I noticed the stunted trees along the rim and the dark dots of shrubs growing within the Canyon. White-throated swifts darted by, tumbling and laughing. Out on a thermal, several turkey vultures teetered on dihedral-held wings. Life here is tenuous but tenacious.

Even after more than four decades, I still get that little-kid, butterflies-in-the-stomach thrill when I go to the Grand Canyon. I gaze into it briefly, look away, blink once or twice, and peer at the gorge again—never quite sure if it is real. From my first visit as a child, I knew that I had to explore this magnificent place, try to understand it in some way. I was fortunate to live in nearby Flagstaff. Weekends and holidays could be spent hiking the Canyon's trails, unraveling its topography. And later as a field biologist, I struggled to fathom the Canyon's complex web of life.

I have discovered there is no way to fully comprehend the place; it's just too big; its scale is totally out of proportion to our daily lives; its riotous colored walls too outlandish; its convoluted landscape too strange. One can learn the statistics: 277 river miles long, averaging a mile in depth, one-half to eighteen miles wide, covering over one million acres, one-third of the earth's geologic history exposed, a United Nations World Heritage Site. One can try to capture the Canyon on film or in a painting or with words, but these always fall short of the real thing with its many moods and many secret places.

To early explorer John Wesley Powell, the Canyon was the "Great Unknown." After his heroic trip down the Colorado River in 1869, he insisted, "You cannot see the Grand Canyon in one view." Another geologist, Clarence Dutton, agreed: "it is not to be comprehended in a day or a week, nor in a month. It must be dwelt upon and studied, and the study must comprise the slow acquisition of the meaning and spirit of that marvelous scenery."

Even a hundred years later, the Grand Canyon presents us with many mysteries—enigmatic twig figurines cached in hard-to-

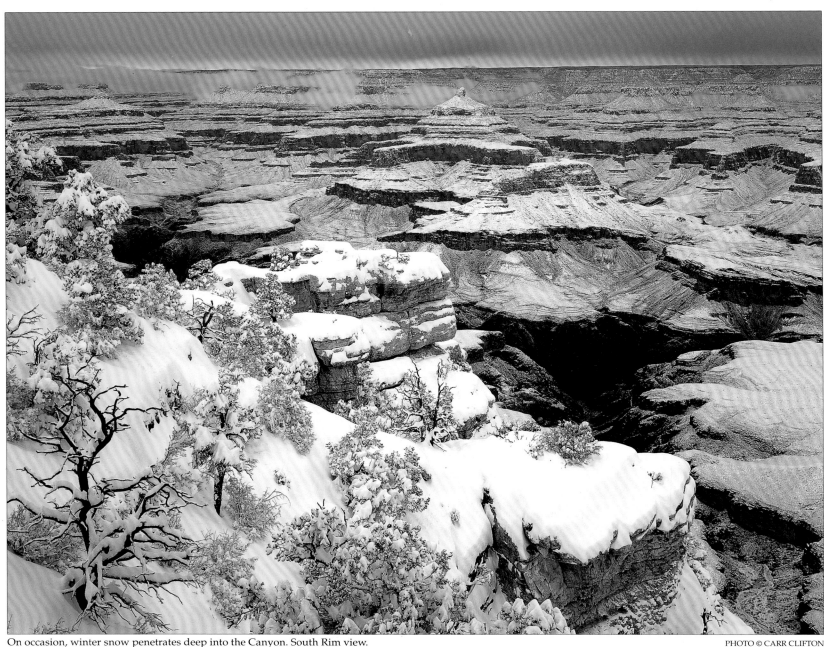

On occasion, winter snow penetrates deep into the Canyon. South Rim view.

reach caves, rivers that burst from the ground, an odd travertine spring revered as the place of human emergence, viridescent elfin gardens of cardinal monkeyflower, columbine, and helleborine orchids besieged by sun-blasted desert, a prehistoric wooden bridge that goes to nowhere or everywhere, rumors of miniature horses, ghost cities, hidden dutch ovens of gold, marine fossils in freshwater limestone, butterflies found nowhere else in the world, the Cambrian explosion of life. A tangle of puzzles, from the preposterous to the profound, lie within a labyrinth of gorges. And the Grand Canyon lures us in.

The train whistle blows. Time to go. But I'll be back again.

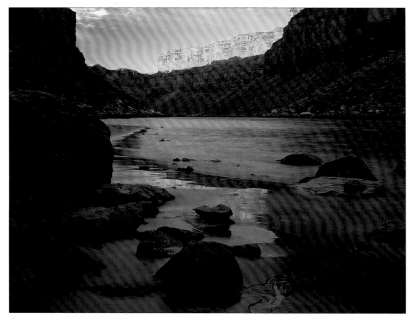

Colorado River in Marble Canyon below Badger Rapid.

ILLUSTRATION BY DARLECE CLEVELAND

Millions of people have seen some of the Grand Canyon, usually from the paved roads along the South or North rims. Tens of thousands have seen the Canyon from river level while bravely shooting the rapids. Some challenge its steep trails. But few know the Canyon intimately in its entirety. Places like Malgosa Canyon, Big Point Canyon, Willow Canyon, Boysag Point, and Yumtheska Mesa are only a few of the many splendidly lonely and unknown places.

The Grand Canyon as a topographic feature extends from Lees Ferry to the Grand Wash Cliffs and is located in the southern portion of a larger physiographic province known as the Colorado Plateau. The Colorado Plateau covers northwestern New Mexico, western Colorado, much of eastern and southern Utah, and northern Arizona. This region is composed mostly of sedimentary rocks deposited in horizontal layers which have

been uplifted an average of one mile above sea level. These rock layers have been carved by the Colorado River and its myriad tributaries into a maze of canyons. There is no other place on earth quite like the geologic wonderland of the Colorado Plateau.

Although the Grand Canyon is one, albeit large, physical entity, it is not an ecological island. A diverse group of agencies, each with its own agenda and often composed of departments with differing goals, manages the Canyon and its bordering lands. Various sections of the Canyon fall under the jurisdiction of the National Park Service, as Glen Canyon National Recreation Area, Grand Canyon National Park, and Lake Mead National Recreation Area; three Indian reservations: Navajo, Havasupai, and Hualapai; the U.S. Forest Service; the Bureau of Land Management; as well as state and local governments.

Perhaps the ultimate management directive for the Canyon was proclaimed by President Theodore Roosevelt, nearly a century ago: "What you can do is keep it for your children, your children's children, and for all who come after you." Obviously, the challenges of protecting the Grand Canyon are daunting. The Grand Canyon Trust, a conservation group based in Flagstaff, Arizona is attempting to raise awareness of the fragility of what they term the Greater Grand Canyon area. The Trust's goals for the region include protecting its wildness; maintaining and restoring the health of the terrestrial and aquatic ecosystems; creating and promoting environmentally sustainable human use and development; and building a strong constituency for conservation. No small task, indeed.

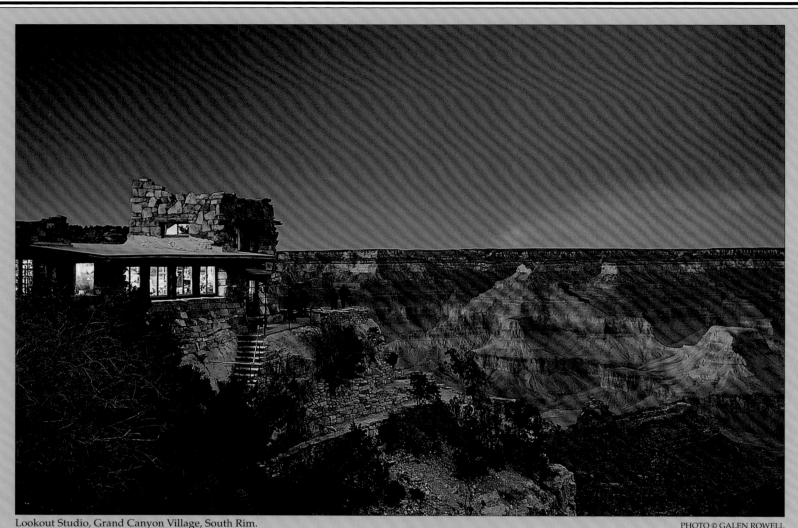

Lookout Studio, Grand Canyon Village, South Rim.

ARCHITECTURE

While the walls of the Grand Canyon record the long history of the earth, buildings record more recent pioneer history. The oldest standing building in Grand Canyon Village on the South Rim is Buckey O'Neill's Cabin. William "Buckey" O'Neill was an author, miner, politician, sheriff, and judge. Like most Grand Canyon pioneers, O'Neill was drawn by the possibility of discovering valuable minerals. In the 1890s he built this log cabin which later became part of Bright Angel Lodge.

Once the train tracks arrived at the South Rim in 1901, the Santa Fe Railroad and Fred Harvey Company took to providing lodging for tourists. In 1904 Chicago architect Charles F. Whittlesey was commissioned to design a hotel on the rim. He combined the qualities of a "Swiss chalet with a Norway villa" in the stately El Tovar Hotel. The hotel, constructed of Oregon pine, was completed the following year. None of the eighty guest rooms had a private bath, but the hotel did boast electricity provided by a steam generator. At a cost of $250,000, the El Tovar was deemed "probably the most expensively constructed and appointed log house in America."

Also in 1904, the Fred Harvey Company hired Mary Jane Colter, one of the first female architects in the United States, to design an Indian house across from the hotel. Colter wanted a structure that represented the history of the area and decided to model this building after the ancient Hopi village of Oraibi. The Hopi House became living quarters for Hopi craftsmen and a store where the Harvey Company sold Indian-made arts and crafts and other souvenirs. Navajos lived in nearby hogans, their traditional log and mud houses.

In 1935, Colter redesigned the Bright Angel Lodge. The stones framing the ten-foot-high fireplace in the Lodge's History Room are from various layers of rock within the Canyon, arranged in geologic order from top to bottom. For the opening of the lodge, Colter decorated the lobby with twenty-five hats from famous westerners, including one of Pancho Villa's sombreros.

The Kolb brothers, Ellsworth and Emery, were photographers who, in 1904, constructed a small building precariously perched on the South Rim. Over the next two decades, the Kolbs added on to their studio until a business and residence of several stories overlooked the head of the Bright Angel Trail. Each morning the descending mule train would pause for the Kolbs to take the riders' pictures. Prints would be ready upon their ascent.

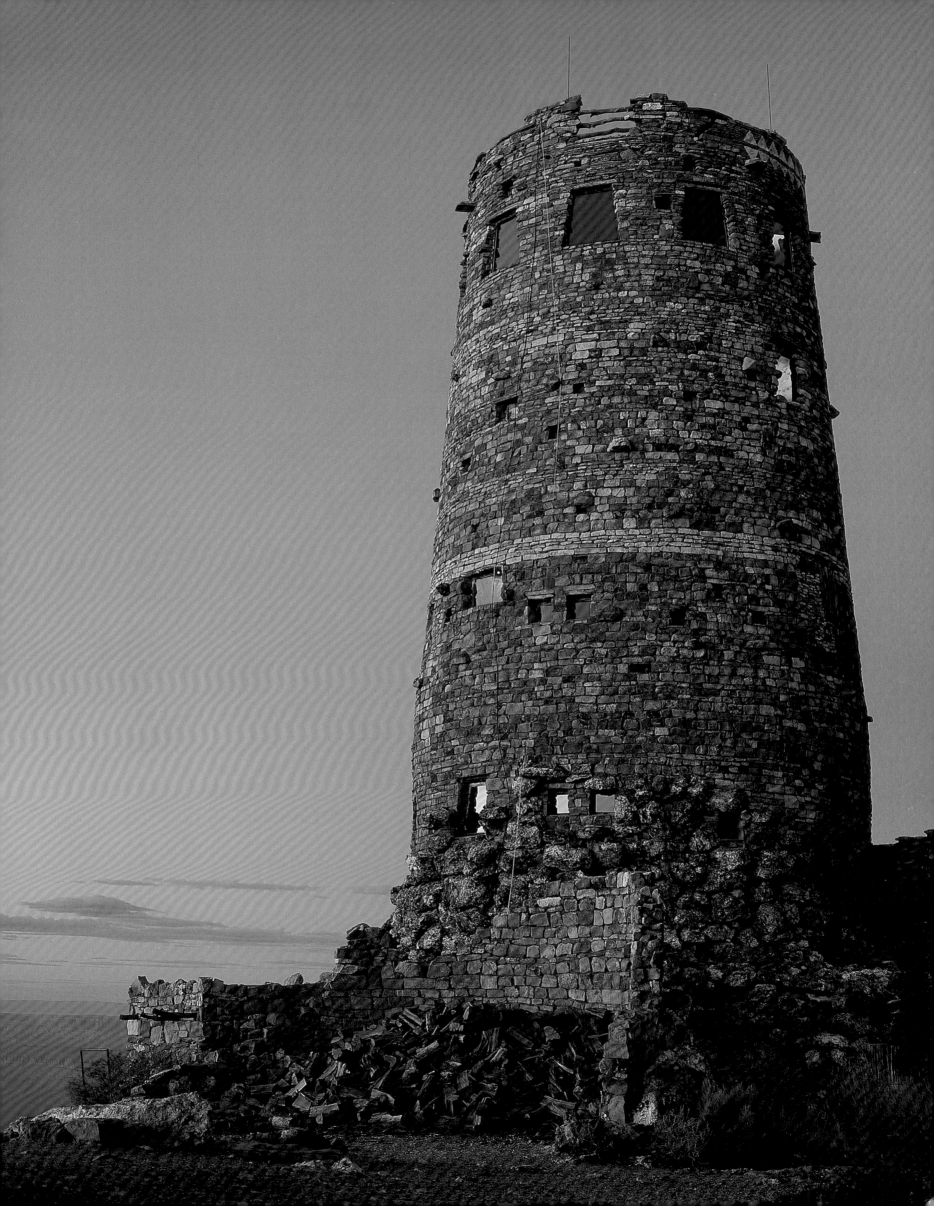

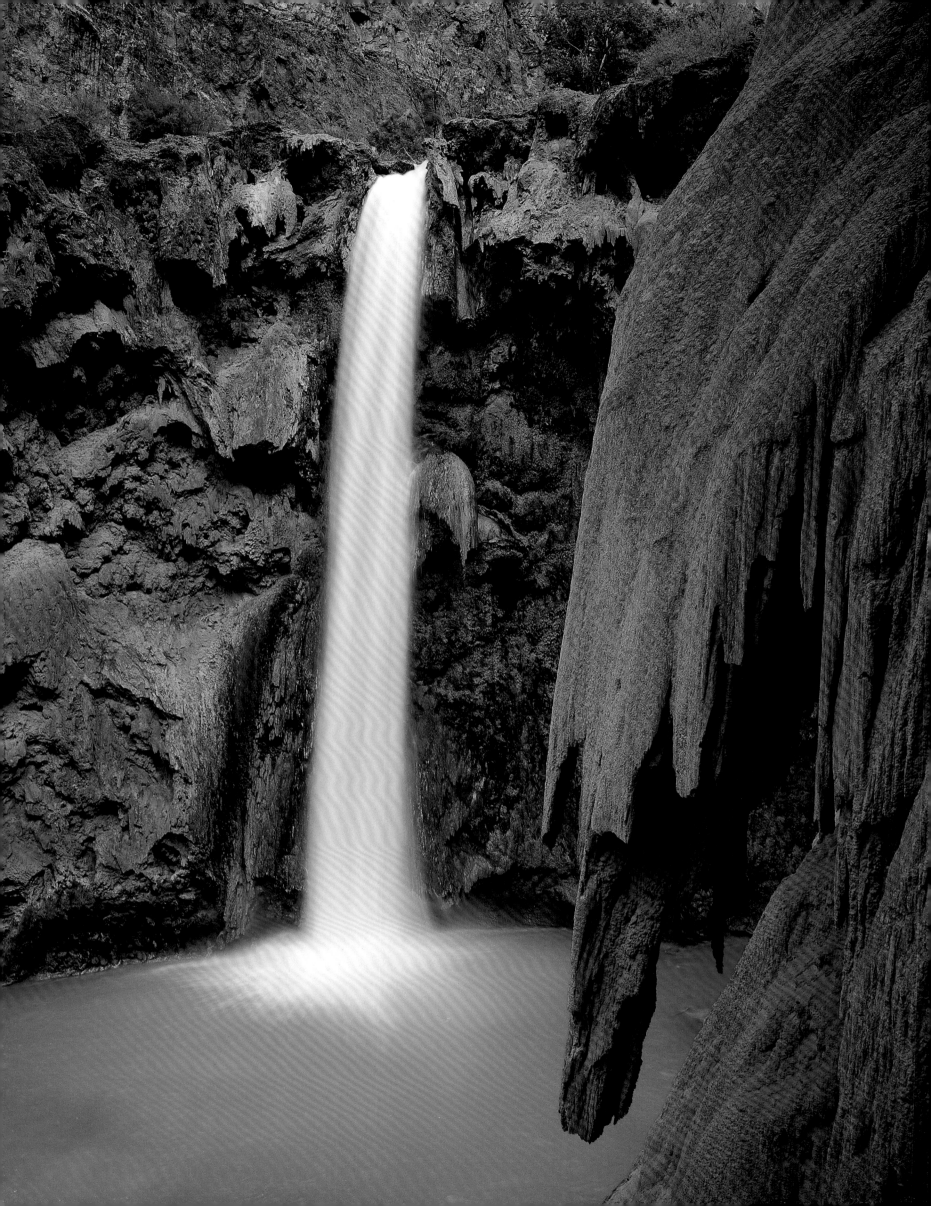

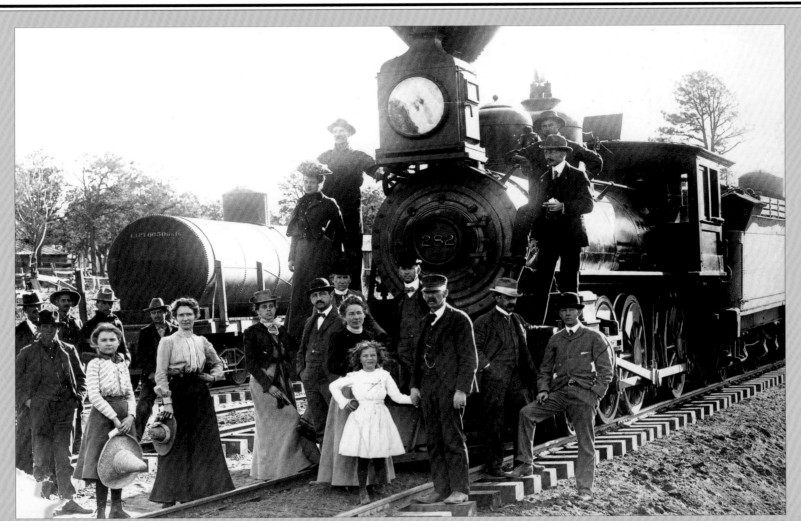

First train to carry passengers to the Grand Canyon, September 17, 1901.

GRAND CANYON RAILROAD

Engineer Robert Brewster Stanton dreamed of building a railroad along the Colorado River through the Grand Canyon. His river-level survey of 1889-90 proved that a rail line could be built to transport minerals to market, but no financial backers were forthcoming.

Six years earlier, in 1883, the Atlantic & Pacific and Atchison, Topeka & Santa Fe Railroad companies joined forces to complete a line across northern Arizona following the Thirty-fifth Parallel, a route originally surveyed for a wagon road in the 1850s. Just three months after the A&P work gangs reached Peach Springs, twenty miles south of the Colorado River, Julius and Cecilia Farlee were ready to ferry train passengers down a rough and dusty road to their newly built hotel along Diamond Creek, the first hotel in or at the Grand Canyon.

Entrepreneur Buckey O'Neill convinced a mining company to build a spur line from Williams to his copper mine at Anita, south of the Canyon. When the mines closed, the rail line went bankrupt but the Santa Fe Railway bought it and finished laying tracks to the South Rim. Congress had authorized Indian Gardens within the Canyon as the terminus, but this section was never constructed.

On September 17, 1901, all twenty-two Grand Canyon Village residents watched the first train pulled by Locomotive 282 roll to a stop at the rim. Now instead of a day or two of jostling in a rough stage for a fare of $15 to $20, one could ride to the Canyon in the relative comfort of the train in three hours for only $4.

Ironically and fatefully, the Santa Fe Railway sponsored the first auto adventure to the South Rim. On January 6, 1902, a steam-powered Toledo Locomobile was expected to make the trip from Flagstaff in under four hours. But after breaking down thirty miles short of the goal and already two days late, it had to be towed by mules the rest of the way to Grandview Point.

After World War II, Americans began visiting the Canyon in ever increasing numbers, most drove in their own cars. Train passenger numbers dwindled, and in 1968 the last train left the Canyon with fewer than 200 passengers aboard. For two decades the abandoned tracks rusted, ties rotted, and trees and shrubs grew between the rails. Then Phoenix businessman Max Biegert decided to reopen the line. In 1989, eighty-eight years to the date from the first train to the South Rim, a vintage steam engine pulling passenger cars was greeted by thousands at the Grand Canyon Depot.

OPPOSITE: Mooney Fall and travertine formations on Havasu Creek, Havasupai Indian Reservation. PHOTO © GARY LADD

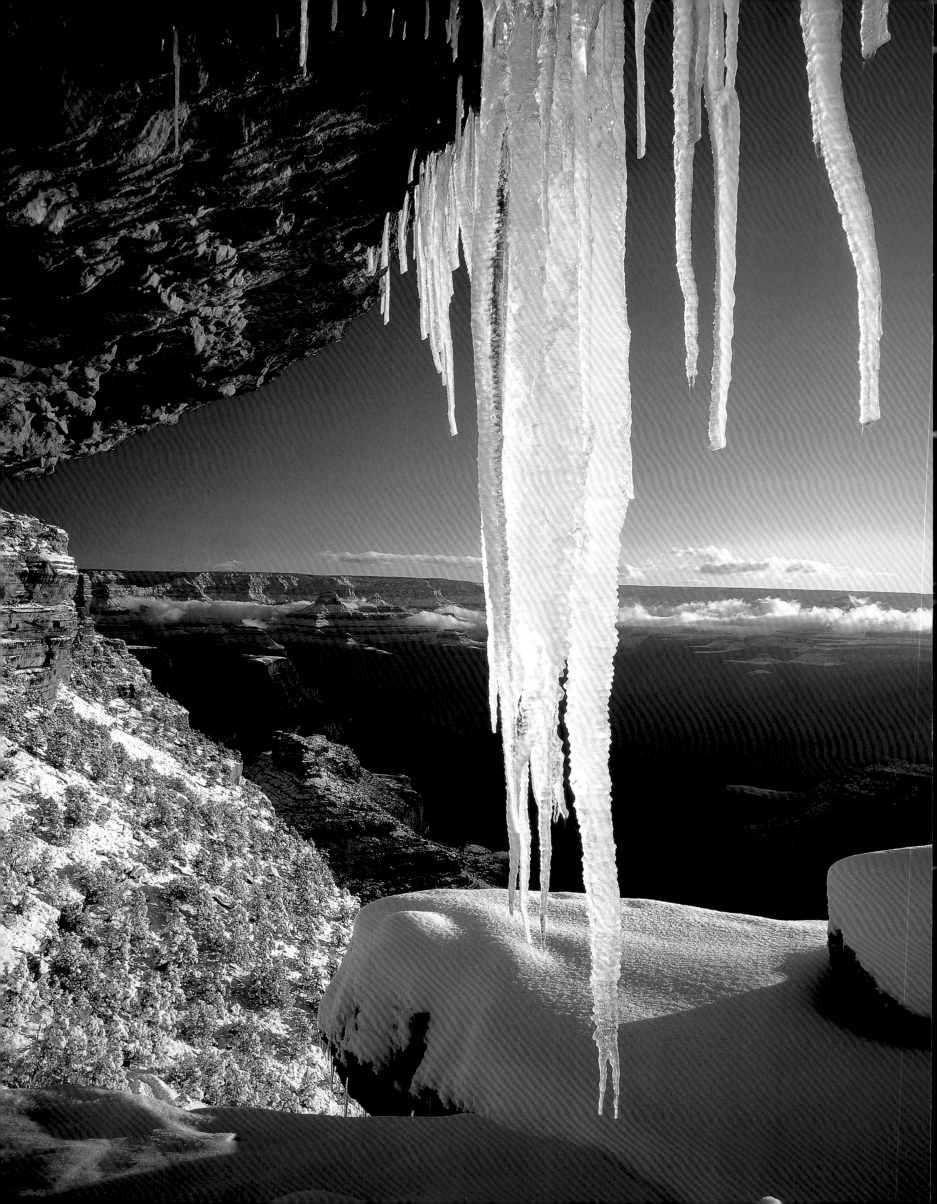

The SOUTH RIM:

The spectacle of sunset from Lipan Point, South Rim. PHOTO © TOM TILL

Nearly five million people a year come through the two South Rim entrance stations and search for a parking space. In a few years, plans call for a new parking area outside the park boundary and a light rail shuttle to whisk tourists to the rim. But until then, it may take a little patience to weather the crush of summer visitation.

Here's a hint: Park your car and take the free West Rim Shuttle. Get off and stroll between the named view points. You'll discover that many folks do not walk even a short distance from their cars. Find a comfortable boulder to sit on or lean against, not too close to the edge, and just soak in the scene. Listen for the *yank, yank, yank* of a white-breasted nuthatch, the *gronk* of a shiny black raven, the tripping-down-the-scale song of the canyon wren, and the wind whispering secrets through the pines. Breathe in the vanilla scent of the ponderosa and the pungent odor of sagebrush, and feel the strong desert sun on your back. Let your thoughts drift across the Canyon with the clouds. Contemplate the play of shadows across the distant cliffs and ledges.

In late afternoon, return to the Grand Canyon Village and walk the short distance down the Bright Angel Trail to the tunnel cut through the limestone cliff. Just beyond the tunnel, look up to your left. Under a large overhang are a dozen or so dark red pictographs of antlered creatures, humanlike forms, and geometric shapes. Long before this was a hiking trail, a couple of hundred, maybe a couple of thousand years ago, a Havasupai or Ancestral Puebloan (Anasazi) crawled up there to paint these figures. Their fine execution suggests they were meant to be more than doodles.

Uplift and faulting through this side canyon broke the sheer cliffs allowing humans access down to the life-giving springs bubbling up on the Tonto Platform below. Indians continued to grow small plots of corn and beans and squash there even after prospectors improved the old route into a mule trail. Ralph Cameron, his brother Niles, and Pete Berry came to the Canyon in 1890 and staked claims along the Indian trail which gave them legal title to it. They charged tourists and others the exorbitant fee of a buck a head plus another dollar for each stock animal.

President Theodore Roosevelt first visited the Canyon in May 1903. While standing on the rim, he instructed, "Leave it [Grand Canyon] as it is. You cannot improve upon it. The ages have been at work on it, and man can only mar it." He then mounted his steed and moseyed down the trail. An apocryphal tale relates that when T.R. reached Indian Garden, he announced to the few Havasupai farmers there, "I am the President, and I am going to make this a national park for the people of the United States. So you folks will have to leave." If nothing else, this illustrates the prevailing arrogance of the federal government toward native people at that time.

Roosevelt did declare the Canyon a national monument in 1908, and the Havasupai eventually abandoned the Indian Gardens area. But Ralph Cameron and company managed to keep control of the Bright Angel Trail.

Rivalry between the Santa Fe Railroad and the Camerons was intense. To prevent its customers from having to pay Cameron, the railroad built the West Rim Drive in 1912 and constructed the Hermit Trail into the Canyon. By 1925 the National Park Service had completed the South Kaibab Trail to also avoid the Bright Angel; however only three years later Cameron lost title to the Bright Angel, and it became a public route.

Meanwhile, Pete Berry also filed mining claims on Horseshoe Mesa below Grandview Point. By 1892, Berry and others had completed the Grandview Trail to bring copper and other minerals to the rim. Even though some of the copper ore assayed at a rich 70 percent pure, the cost of transporting it out of the Canyon and to a smelter proved too expensive. Several years later, Berry built a hotel near the rim and began to take tourists down his trail, but after the railroad reached what would become the Grand Canyon Village, this business venture failed too.

Farther east, near Desert View, is another old Indian route. Seth Tanner, a Mormon pioneer and occasional prospector from Tuba City, decided in the 1880s to improve the route. There were rumors that infamous Mormon John D. Lee had buried dutch ovens full of gold in the Canyon. Perhaps Tanner hoped to find this hidden treasure; instead, after a half dozen years of searching,

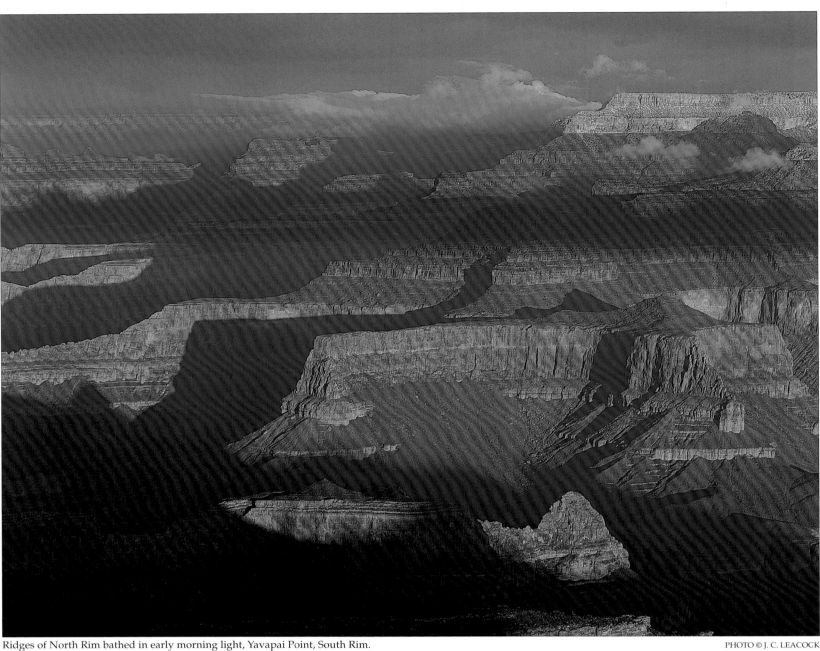

Ridges of North Rim bathed in early morning light, Yavapai Point, South Rim.

he located copper and silver deposits in Palisades Creek. The path became known as the Tanner Trail.

To improve access, prospector Franklin French relocated the upper section of the trail to its present location near Lipan Point. According to French, "We called it a trail, but it was only a roughly marked out suggestion of where a trail ought to be." In attempting to get supplies to the river, he recounted, "Drunken men will often do things they dare not attempt when sober. I thought I would try it on the mules...when they drank, I dosed the water heavily with whiskey...The mules were as reckless as Jack Tars on a frolic. We got there all the same, but a sorrier looking set of remorseful, repentant mules than we had the next morning the eye of man never saw."

If you're still having trouble finding that parking space, just blame it on Teddy Roosevelt. Almost a hundred years ago, he implored, "Keep it [Grand Canyon]...as the one great sight which every American...should see."

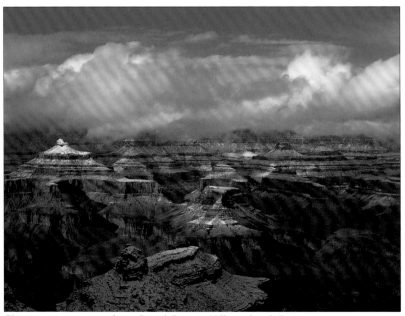

Clearing winter storm from Grand Canyon Village, South Rim.

ILLUSTRATION BY DARLECE CLEVELAND

The Grand Canyon Village is the main center for lodging, meals, and Canyon information. Along with the historic El Tovar Hotel and Bright Angel Lodge, are the newer Kachina and Thunderbird lodges. The less expensive Maswik and Yavapai lodges and Mather Campground are located a little farther away in the pine forest. Eating establishments range from the simple, inexpensive Bright Angel Fountain to the elegant El Tovar Dining Room (no shorts, please). A general store carries groceries and camping equipment.

For general information, as well as books and displays about the park, a stop at the **Visitor Center** and a free copy of *The Guide* is a must. (A free *Accessibility Guide* is available at the Visitor Center for physically challenged visitors.) The nearby **Yavapai Observation Station** and the Kolb Studio offer more information and books.

Near Maswik Lodge is the Backcountry Office where permits for overnight backpacks into the Canyon can be obtained (see Hiking the Inverted Mountains for more information).

From the village area a scenic eight-mile road skirts the rim to the west—the West Rim Drive. Another road leading to the east—the East Rim Drive (State Highway 64)—eventually leads to Cameron and U.S. Highway 89.

One of the two maintained rim-to-river trails, the **Bright Angel Trail**, begins next to Kolb Studio. The other trail, the South Kaibab, is located off the East Rim Drive near Yaki Point. Both lead to the Bright Angel Campground and Phantom Ranch, the only developed tourist facilities at the bottom of the Canyon. At the river, a trail connects the South Kaibab to the Bright Angel.

During the busy summer months, free shuttle buses transport visitors around the village area and out on the West Rim Drive. Scheduled for completion in the near future is the Canyon View Information Plaza. The plan calls for day-use visitors to travel by light rail from the gateway community of Tusayan to the plaza six miles north. At **Mather Point**, an orientation center will help visitors find their way around the Canyon by bus, on foot, or by bicycle.

In addition, nine historic buildings in the village area are to be transformed into a visitor discovery and education complex, providing in-depth educational opportunities. Also planned is a new trail system to promote pedestrian and bicycle travel along the South Rim from Hermits Rest to Desert View.

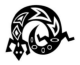

WEST RIM DRIVE

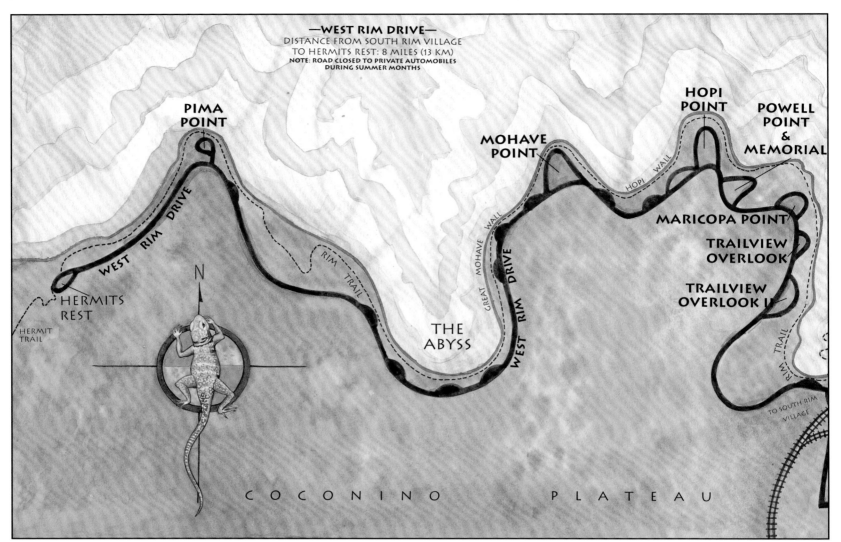

—WEST RIM DRIVE—
DISTANCE FROM SOUTH RIM VILLAGE
TO HERMITS REST: 8 MILES (13 KM)
NOTE: ROAD CLOSED TO PRIVATE AUTOMOBILES
DURING SUMMER MONTHS

ILLUSTRATION BY DARLECE CLEVELAND

The West Rim Drive winds about eight miles from Grand Canyon Village to Hermits Rest. During the summer, the road is closed to private vehicles, but a free shuttle bus service makes frequent stops at several points along the way.

From **Trailview and Trailview II** look back to the south to see the village. Bright Angel Trail drops off the rim next to the old Kolb Studio. Below, Indian Garden Campground is recognizable by the large Fremont cottonwood trees growing along Garden Creek.

The long, straight canyon carved far into the North Rim by Bright Angel Creek is strikingly apparent from **Maricopa Point**. The creek has followed the trace of the Bright Angel Fault, a major fault that runs nearly perpendicular to the course of the Colorado River.

The Orphan Mine headframe is visible from **Powell Point**. Daniel Hogan discovered copper here in 1893, but a more valuable deposit of uranium was mined from 1954 until 1966. The Canyon's small deposits of copper, silver, and uranium are the result of a geologic feature known as a breccia pipe. These "pipes" formed when the roof of a cave in the Redwall Limestone collapsed. Pieces of rock (breccia) from the overlying formations tumbled into the cave. Groundwater carried down dissolved minerals which precipitated out in the breccia.

Directly across the canyon from **Hopi Point** is Shiva Temple, an isolated mesa that was once joined to the North Rim. In 1937, the American Museum of Natural History mounted an expedition to look for unique species of small mammals that may have been isolated on Shiva Temple. The popular press had the biologists searching for dinosaurs. Although deer antlers and Pueblo artifacts were found, no unique mammals or large reptiles were seen.

Mohave Point offers a view of three rapids on the Colorado River—Hermit, Granite, and Salt Creek. **The Abyss**, at the head of Monument Creek, drops a breathtaking 3,000 feet to the Tonto Platform. Remnant stands of Douglas fir and white fir on the north-facing cliffs are a biological window to the last ice age.

Looking down from **Pima Point** parts of the Hermit Trail, constructed in 1911, can be seen winding down to the square outlines of cabin foundations and the corral of a guest ranch built by the Santa Fe Railroad. The camp was abandoned in 1930 after the Bright Angel Trail became a free, public route.

The West Rim Drive ends at **Hermits Rest**, another rustic stone building designed by Mary Colter in 1914. This is also the trailhead for the unmaintained Hermit Trail.

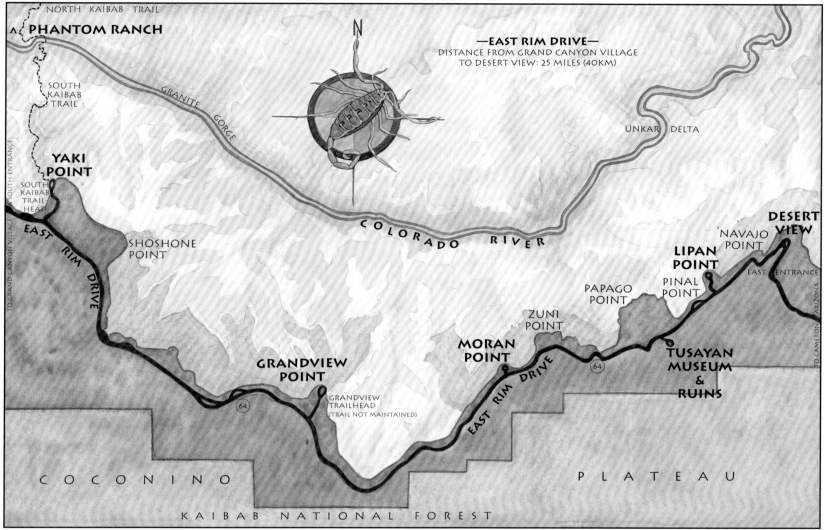

—EAST RIM DRIVE—
DISTANCE FROM GRAND CANYON VILLAGE
TO DESERT VIEW: 25 MILES (40KM)

ILLUSTRATION BY DARLECE CLEVELAND

The East Rim Drive meanders about twenty-five miles from the village area to Desert View.

At Yavapai Point is an observation room and bookstore. From here, it's possible to see **Phantom Ranch**, the only tourist lodge within the Canyon, nestled along Bright Angel Creek. The Kaibab Suspension Bridge spanning the Colorado River is also visible. The bridge is 440 feet long and about 60 feet above the river. The bridge's ten, one-ton cables were hand-carried into the Canyon by forty-two Havasupai men in 1928.

Coming into the park through the South Entrance, most visitors stop at Mather Point, named after Stephen Mather, first director of the National Park Service.

Sections of the South Kaibab Trail, which begins nearby, can be seen from **Yaki Point**. (In the summer, access to this point may be limited to shuttle buses.) Across the Canyon and a little to the northeast, Clear Creek has cut a long gash into the North Rim. In the spring, a white spot appears in the Redwall Limestone cliff overlooking upper Clear Creek. This is Cheyava Falls, a seasonal waterfall, which bursts from a cave and drops nearly a thousand feet.

The old mining and tourist trail to Horseshoe Mesa begins at **Grandview Point**.

Although named for his brother Peter, **Moran Point** could easily commemorate nineteenth-century landscape painter Thomas Moran. His paintings helped convince Congress to establish Grand Canyon National Park in 1919.

Tusayan Ruin is an Ancestral Puebloan (Anasazi) site that was occupied during the twelfth century. A short interpretive walk around the excavated ruin and a small museum explain the site.

Lipan Point offers an exceptional view of the Colorado River. To the north, the river flows through an open valley, curves sharply past the delta of Unkar Creek where an Ancestral Puebloan village once stood, and then crashes through Unkar Rapids, a twenty-five-foot drop. To the west, the Colorado thunders over Hance Rapids and plunges into the dark Inner Gorge. To the south, the San Francisco Peaks, sacred mountains to the Hopi and Navajo, dominate the horizon.

Desert View is the easternmost overlook on the South Rim. There is an information center and bookstore, grocery store, curio shop, snack bar, service station, campground, and the distinctive Watchtower. The seventy-foot-high stone tower was conceived by Mary Colter and built in 1932 with Hopi labor. The tower resembles those built by the Ancestral Puebloan; inside are objects and paintings depicting Hopi legends.

PAGE 24/25: Wotans Throne, Vishnu Temple, and a late-afternoon rainbow seen from Yaki Point, South Rim. PHOTO © TOM BEAN

GEOLOGY: A SEDIMENTARY JOURNEY

The rocks of the Grand Canyon have attracted people for thousands of years. Native people collected red and yellow ocher for paint and medicine and gathered sacred salt from caves. The Spanish came in search of gold but left empty handed. The lure of valuable minerals brought American prospectors, but the limited deposits of copper and asbestos were difficult to extract and too costly to ship to market.

In 1869, geologist John Wesley Powell's successful trip down the Colorado River and subsequent report and popular articles revealed the geologic wonder of the region to the general populace. The Canyon walls held more than mineral wealth.

Each colorful layer of rock exposed in the walls of the Canyon is a window back to a different time and environment. The oldest layers (Proterozoic Era), those exposed at the very bottom, date back 1.7 billion years before the present, an incomprehensibly long time ago. Sedimentary and igneous rocks were subjected to intense heat and folding to become high mountains of metamorphic schists, gneisses, and granites (the **Vishnu Group**). After a half billion years, erosion had worn these mountains down to a nearly level plain. An ocean invaded and muds, sands, and limy muds accumulated for another 300 million years to a thickness of 12,000 feet; these are collectively called the **Grand Canyon Supergroup**. About 900 million years ago, these sediments were lifted upward, faulted into blocks, and tilted to create mountains and intervening valleys. After another 330 million years, this uplifted terrain was eroded into a lowland of small hills and broad valleys. The blocks that were faulted downward were protected from erosion and are still visible as tilted layers along the river in eastern Grand Canyon and also near the foot of the South Kaibab Trail.

Above these very ancient rocks are a series of horizontal beds. The contact where the first flat-lying strata (usually the Tapeats Sandstone) rests on the older schists, granites, or tilted strata was named the **Great Unconformity** by Powell, a gap in time of up to 830 million years.

During this time, life on earth was making the giant leap from single-celled organisms to more complex creatures. By the time the next ocean covered the region, some 550 million years ago, there had been an explosion of new life forms. Preserved within the **Tapeats Sandstone**, **Bright Angel Shale**, and **Muav Limestone**, all three layers deposited in this ocean, is an amazing fossil record of trilobites, marine worms, jellyfish, and a myriad of other marine animals.

Slowly the sea retreated, the top of the Muav was exposed to erosion, and streams and rivers meandered across the surface. The sediments deposited in the river channels became the **Temple Butte Limestone**.

Another long period of erosion was followed by the invasion of another shallow, warm sea where more marine limestone was deposited to form the massive **Redwall Limestone**. The purity of this limestone suggests that calcium carbonates from onshore were emptying into this sea. Calcium carbonate was also precipitated out on the ocean floor along with the shells of billions of sea animals.

The next thousand feet of reddish rock are shale, siltstone, sandstone, and some limestone. The upper third is the relatively soft **Hermit Shale**, forming a slope. Fern leaf, rain drop, and insect wing impressions are common fossils in the Hermit. The series of ledges, cliffs, and minor slopes between the Hermit and Redwall is the **Supai Group**. Iron oxides leaching out of these red formations wash down and stain the surface of the Redwall, which is naturally gray.

The land rose, and winds from the north covered the area with deep golden sand dunes. The dunes are preserved as the massive **Coconino Sandstone**, marked with elegant patterns called crossbedding that hint at its windblown origins. Fossilized reptile tracks found in this formation always go up the bedding planes, almost never down. This mystery was solved by watching modern lizards on sand. Going uphill, the animals tend to leave distinct tracks; going down, the lizard's momentum produces blurred tracks.

Eventually the Coconino desert was submerged under a sea and more limestone, sandstone, and gypsum were deposited as the **Toroweap Formation**.

This was followed by a brief erosional period and the invasion of yet another ocean. This sea teemed with mollusks, sea lilies, sponges, trilobites, and brachiopods leaving behind the **Kaibab Formation**. While all these sedimentary rocks, from the Tapeats through the Kaibab, were being laid down, evolution was leading to vascular plants and the first fish, amphibians, and reptiles. Then biological disaster. For reasons still not clear, at the end of the Paleozoic Era came a huge extinction of mainly marine creatures. In terms of the number of species that vanished, it overshadowed the later extinction of the dinosaurs.

The next major geologic era, the Mesozoic, witnessed a series of sandy deserts and the coming of the terrible lizards—the dinosaurs. Probably 2,000 feet of sandstones and shales covered the Grand Canyon region, but most have been eroded away over the last sixty-five to seventy million years (Cenozoic Era). Mesozoic rocks still exist north and east of the Canyon as the Vermilion Cliffs, Kaibito and Paria plateaus, and as small isolated remnants such as Shinumo Altar, Gold Hill, Cedar Mountain, and Red Butte.

The story of how the Grand Canyon came to be is one of weathering, erosion, and transport, but the details are still shrouded in mystery. Powell believed that at one time an ancestral Colorado River flowed across a relatively flat plain. Part of the plain began to rise into a oblong highland—the Kaibab Plateau. The river's relentless downcutting was able to match the slow rising of the surrounding ground. The river's ancient course was maintained as the deep canyon was carved. Powell and other early geologists concluded that the Canyon must be extremely old, perhaps fifty million years or more. A beautiful, simple, elegant theory, but wrong.

Geologists have since determined that the Kaibab Plateau was uplifted long before the river carved the Canyon through it. Does this mean that the river had to flow uphill in the past, to get over the Kaibab Plateau? No, of course not. But it does present a perplexing problem.

Maybe more than one river was involved.

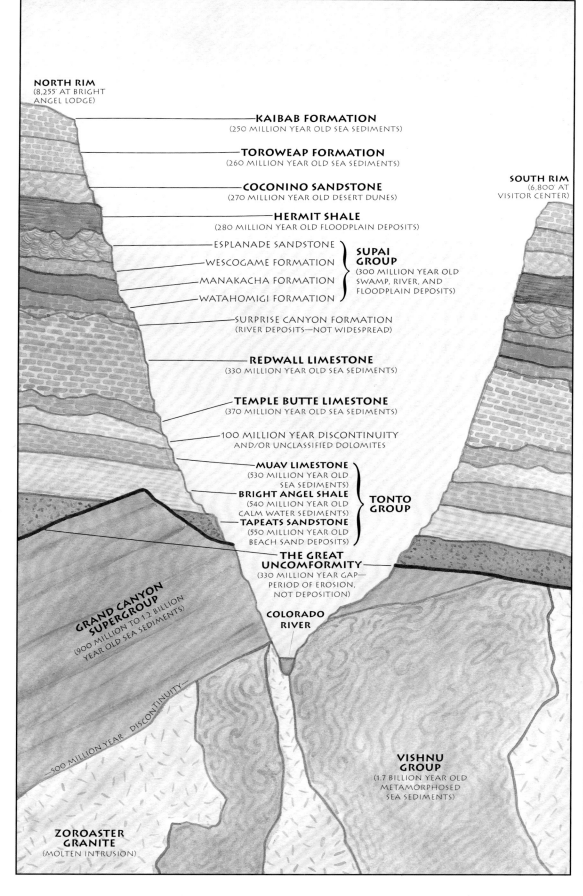

NORTH RIM
(8,255' AT BRIGHT
ANGEL LODGE)

KAIBAB FORMATION
(250 MILLION YEAR OLD SEA SEDIMENTS)

TOROWEAP FORMATION
(260 MILLION YEAR OLD SEA SEDIMENTS)

COCONINO SANDSTONE
(270 MILLION YEAR OLD DESERT DUNES)

SOUTH RIM
(6,800' AT
VISITOR CENTER)

HERMIT SHALE
(280 MILLION YEAR OLD FLOODPLAIN DEPOSITS)

ESPLANADE SANDSTONE
WESCOGAME FORMATION
MANAKACHA FORMATION
WATAHOMIGI FORMATION

**SUPAI
GROUP**
(300 MILLION YEAR OLD
SWAMP, RIVER, AND
FLOODPLAIN DEPOSITS)

SURPRISE CANYON FORMATION
(RIVER DEPOSITS—NOT WIDESPREAD)

REDWALL LIMESTONE
(330 MILLION YEAR OLD SEA SEDIMENTS)

TEMPLE BUTTE LIMESTONE
(370 MILLION YEAR OLD SEA SEDIMENTS)

100 MILLION YEAR DISCONTINUITY
AND/OR UNCLASSIFIED DOLOMITES

MUAV LIMESTONE
(530 MILLION YEAR OLD
SEA SEDIMENTS)

BRIGHT ANGEL SHALE
(540 MILLION YEAR OLD
CALM WATER SEDIMENTS)

TAPEATS SANDSTONE
(550 MILLION YEAR OLD
BEACH SAND DEPOSITS)

**TONTO
GROUP**

**THE GREAT
UNCONFORMITY**
(330 MILLION YEAR GAP—
PERIOD OF EROSION,
NOT DEPOSITION)

**COLORADO
RIVER**

**GRAND CANYON
SUPERGROUP**
(900 MILLION TO 1.2 BILLION
YEAR OLD SEA SEDIMENTS)

500 MILLION YEAR DISCONTINUITY

**VISHNU
GROUP**
(1.7 BILLION YEAR OLD
METAMORPHOSED
SEA SEDIMENTS)

**ZOROASTER
GRANITE**
(MOLTEN INTRUSION)

The Canyon seems to be relatively young, perhaps between 1.7 to 6 million years old. That's a mind-boggling amount of erosion in such a short geologic time. All that can be said for certain is that a river system is responsible for the downcutting. Other kinds of erosion, such as frost-wedging, widen the Canyon. The stairstep profile of the Canyon to due to the varying hardness of each rock layer: softer ones form slopes, the harder layers tend to be cliffs.

Also notice the striking asymmetrical profile of the Canyon. The South Rim is about two miles from the river whereas the North Rim is about five to six miles away. Both rims dip slightly to the south. Rain hitting the South Rim tends to run away from the Canyon. Precipitation landing on the North Rim tends to run into the Canyon, thus side canyons are longer and cut more deeply on the north side.

After the Canyon was carved nearly to the dimensions we see today, molten rock oozed out of cracks in the earth and poured over the western Grand Canyon landscape. At least twelve times, magma flowed into the Canyon and hissed and sizzled as it met the Colorado River, cooling and hardening into dams. The greatest of these occurred a little over a million years ago and created a lake about 2,300 feet deep. Eventually these lakes overtopped the dams and wore them away.

To view the Grand Canyon is to peer through a window of time. The scene is fraught with contradictions, inconsistencies, and unresolved questions. As conservationist John Muir wrote many years ago, "the whole cañon is a mine of fossils...forming a grand geological library." Geologists are still trying to read the whole story.

ILLUSTRATION BY DARLECE CLEVELAND

ABOVE: Redwall Limestone boulder, Saddle Canyon. PHOTO © CHRISTOPHER BROWN

The NORTH RIM:

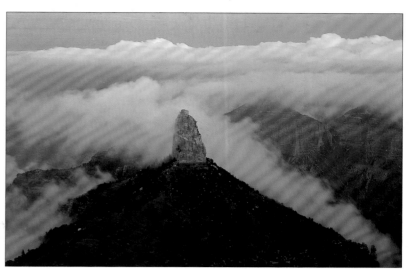

Mt. Hayden in late-afternoon fog, Point Imperial, North Rim. PHOTO © JACK DYKINGA

The region from the Canyon northward to the Utah border is known as the Arizona Strip, politically connected but geographically isolated from the rest of Arizona. Within the Strip, the Kaibab Plateau rises abruptly to over 9,000 feet, forming a biological island surrounded by a sea of desert. Unlike the South Rim where entrepreneurs, prospectors, schemers, and dreamers arrived early, exploration was longer in coming on the North Rim. The high country is buried under deep snows half the year, and the lower deserts are crossed by only a few meager, mostly unpaved roads.

One way to reach the North Rim is to take U.S. Highway 89 north from Flagstaff. Sections of the highway follow the old Mormon Honeymoon Trail wagon road which traces an even earlier Indian path. There is no hint of a canyon until Highway 89A bridges the Colorado near the head of the Grand Canyon at Lees Ferry, a place where the famous, and infamous, have crossed paths. In the winter of 1776, two Spanish padres attempted to swim across the river here. A century later, it became the hiding place for John D. Lee who had been implicated in the Mountain Meadow Massacre in southwest Utah. Later, Teddy Roosevelt and writer Zane Grey used the ferry service started by Lee. When the ferryboat capsized in 1928, three men, a Model T Ford, and the boat were lost. With the Navajo Bridge almost completed, the ferry never operated again. A new bridge has replaced the old one, which is now a pedestrian way. There is also a visitor center.

The highway swings around the base of the Vermilion Cliffs, arrows across the Marble Platform, and then begins the steep climb up the wavelike crustal fold called the Kaibab Monocline. Hope for a glimpse of one of the recently introduced California condors. On top of the Kaibab Plateau, turn south at Jacob Lake for the forty-five-mile journey through lovely ponderosa, fir, spruce, and aspen forest broken by verdant meadows.

When I think about the North Rim, I remember mostly the forest. The Canyon, as incredible as it is, almost serves only as a backdrop to the magnificent trees. Maybe it's the Canyon's vastness that strains my vision; my appreciation falters. After all, geologist Clarence Dutton proclaimed that the Canyon is "a great innovation of our modern ideas of scenery." In the forest, it is cool and green, a refuge of subdued light, familiar, friendly. Beyond the trees, the Canyon shouts for attention—a harsh, blare of bright sunlit cliffs, temples, slopes of riotous colors, a terrible gash in the breast of the earth, but I tune into the forest sounds.

The eerie, liquid flutelike phrases of a hidden hermit thrush drift by, a cautious bobcat creeps down to Harvey Pond for a drink, mule deer browse at the edge of DeMotte Park ("park" being an old cowboy term for meadows), wild turkeys gobble across the road, and I see the flash of a snowy white tail on the south end of a northbound Kaibab squirrel.

I wait until evening to make the short walk from the North Rim Lodge to Bright Angel Point. The light is softer now; the Canyon's colors richer. I can hear the rush of water far below at Roaring Springs. This large spring is the source of drinking water for both North and South Rims. The inner secret parts of the Canyon are already in deep shadow. Brahma and Zoroaster temples glow in the waning light. Far to the south, the San Francisco Peaks oversee a phalanx of lesser volcanoes.

In 1907, a young dentist from Ohio came to the North Rim to learn more about Buffalo Jones' experiments in crossing bison bulls with black Galloway cows to produce a hybrid that would hopefully display the better qualities of each parent. Also, Buffalo Jones promised to take the dentist "ropin' for lions."

Out on the Powell Plateau, Jones' hunting hounds would tree a mountain lion and, unbelievably, Jones would climb into the tree and lasso the angry cat. The incredulous young Ohioan took pictures and kept detailed notes. Later he rejected dentistry to write a novel based upon his summer adventure entitled, *The Last of the Plainsmen*. His nom de plume was Zane Grey.

On the east side of the Kaibab Plateau, Point Imperial overlooks Nankoweap Canyon where in 1993 a diagnostic Folsom stone point was discovered, proving that Paleolithic hunters were in the Grand Canyon at least 10,000 years ago. In 1882 an old Indian trail into Nankoweap was improved to provide horse access. The eminent paleontologist Charles Doolittle Walcott spent

OPPOSITE: Autumn color in Roaring Springs Canyon, late-afternoon, North Rim. PHOTO © TOM ALGIRE

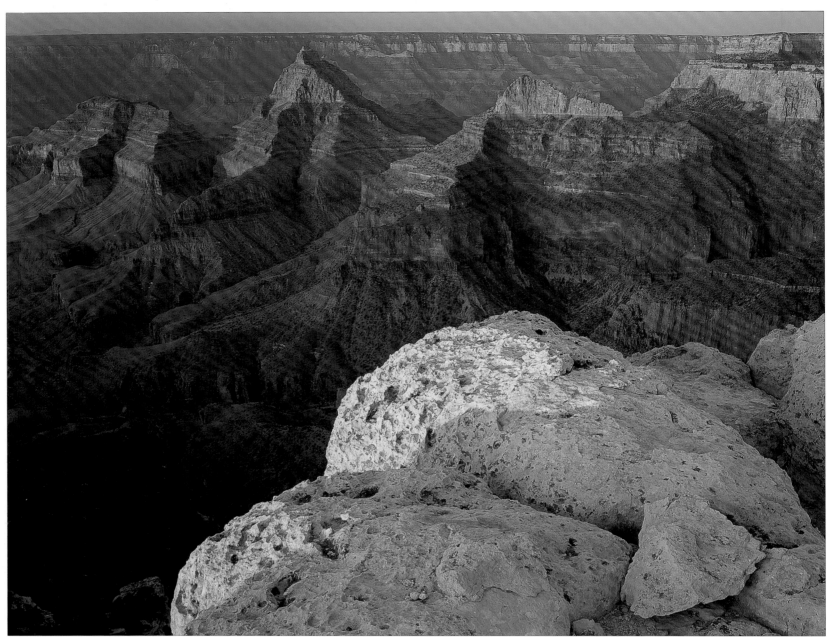
From left to right: Krishna Shrine, Vishnu Temple, and Freya Castle seen from near Cape Royal, North Rim.

seventy-two days in the inner canyon studying the ancient, tilted rock layers.

Within a couple of years, horse thieves connected the Nankoweap Trail with a prospector trail—the Tanner—on the south side of the river to form a cross-canyon route. Stolen Utah horses were sold in Arizona and vice versa. Not only was the trail arduous, but swimming the Colorado could be fatal for man and beast.

Did these outlaws notice the seashell fragments in the Kaibab Limestone? Did they puzzle over the reptile tracks petrified in the Coconino Sandstone? Did they wonder over the fern frond and dragonfly wing impressions in the Hermit Shale? As their horses kicked up dust around Nankoweap Butte, were they fooled by the gold-colored spheres of marcasite (a relative of iron pyrite) eroding out of the rocks?

They were probably blinded by greed. And me? I can't see the Canyon for the trees.

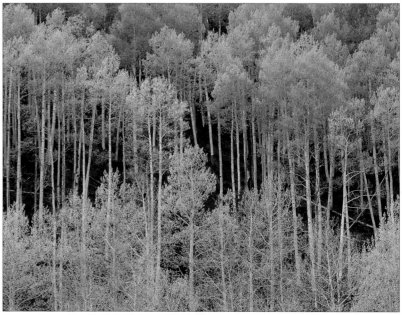
Aspens in spring, Kaibab Plateau, North Rim.

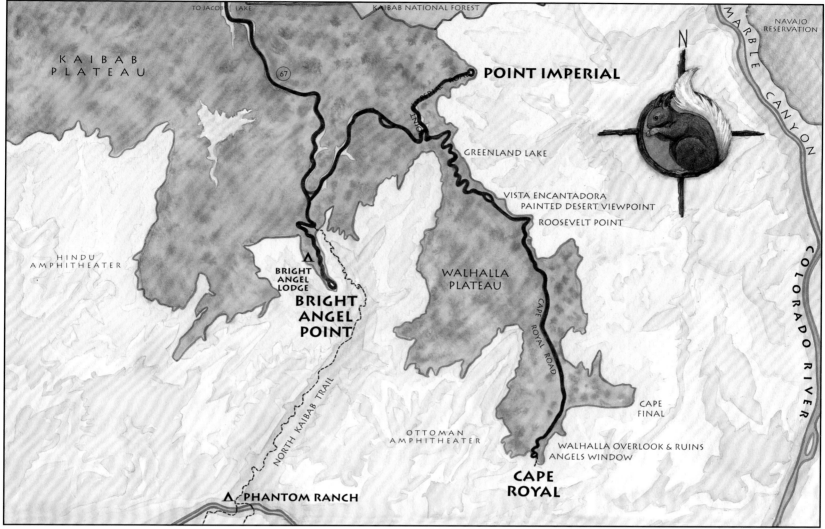

ILLUSTRATION BY DARLECE CLEVELAND

Approaching the North Rim is like entering another world. Drive from the east or north and U.S. Highway 89A climbs out of desert scrub first into pinyon pine and juniper woodland, then quickly into stately ponderosa pine forest. Heading south from Jacob Lake, State Highway 67 continues to ascend into spruce, fir, and aspen.

Tourist facilities on the North Rim such as the Grand Canyon Lodge, campground, park service visitor center, and stores, are open from mid-May to mid-October. The road from Jacob Lake to the North Rim, across the Kaibab Plateau, usually stays open until early November.

A paved park service road leads east and south to spectacular views at **Point Imperial**, Vista Encantada, Roosevelt Point, Walhalla Overlook, and **Cape Royal**. Check at the visitor center regarding access to Point Sublime, a spectacular viewpoint west of the North Rim village area.

Pleasant rim walks range from the half-mile trail from the lodge to **Bright Angel Point** to the ten-mile-long Ken Patrick Trail that goes from the head of the North Kaibab Trail to **Point Imperial**. Do remember the high elevation. Plan six to eight hours for the nine-mile descent and return on the North Kaibab Trail to Roaring Springs. It's about 14 miles one way from the rim to Phantom Ranch.

The rim area north of the Colorado River is made up of five distinct plateaus. East to west, they are the Marble Platform, Kaibab, Kanab, Uinkaret, and Shivwits plateaus. What is commonly called the North Rim is actually just the southern portion of the Kaibab Plateau.

The Grand Canyon Lodge was designed by Gilbert Stanley Underwood, who also designed the Ahwahnee Hotel in Yosemite and the lodges in Bryce and Zion. The Grand Canyon Lodge was completed in 1928, but tragically burned down in 1932. It was rebuilt five years later with better fireproofing. From the lodge, it is only ten raven-miles to Grand Canyon Village on the South Rim, by trail the distance is about twenty miles, and by road, more than 200 miles.

For those prepared with the proper vehicle, supplies including water and a good map, and patience, a sixty-mile dirt road leaves State Highway 389 about nine miles west of Fredonia and travels to the Toroweap Overlook, where there is a campground but no water. Here the Canyon walls drop nearly 3,000 vertical feet to the Colorado River. Lava Falls, one of the biggest of the river's rapids, can be seen downstream.

Farther west is the Uinkaret Plateau, a place of pine forest stands separated by inhospitable lava flows. Beyond is the unprotected Shivwits Plateau which is being considered for national monument status.

LIFE ZONES

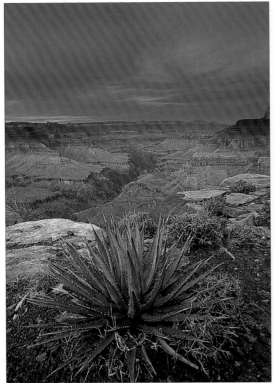

Agave at sunset. PHOTO © TOM BEAN

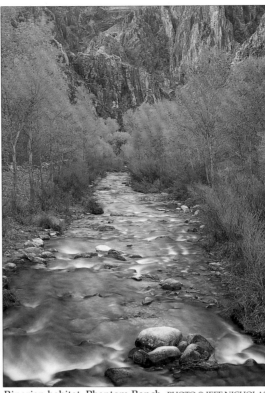

Riparian habitat, Phantom Ranch. PHOTO © JEFF NICHOLAS

Ponderosa Pine Forest, South Rim. PHOTO © GREG PROBST

On a warm September day in 1889, government biologist Clinton Hart Merriam and his assistant Vernon Bailey started down a prospector's trail into the Grand Canyon. As they descended, they noted that the plant communities changed dramatically. On the rim they had found tall, stately ponderosa pines, and in cool, north-facing ravines a few Douglas fir and white fir were growing. A thousand feet below the rim, they passed through a woodland of pinyon pines and juniper. Another couple of thousand feet brought them into the stark, but not barren, desert scrub of the Tonto Platform. Blackbrush was common. Merriam's legs gave out but Bailey continued all the way to the Colorado River and reported more desert, but this one included brittlebush, honey mesquite, and catclaw acacia. Biologically, their hike was like going from the forests of southern Canada to the Sonoran Desert of northern Mexico.

If they had visited the North Rim above 8,700 feet, they would have encountered a boreal forest of Engelmann spruce, alpine and white firs, and Douglas fir amid groves of quaking aspens.

What causes these changes? Merriam claimed temperature was one of the major forces. Dropping a thousand vertical feet increases the temperature three to five degrees Fahrenheit. Further investigation showed that precipitation also changes with elevation, lower elevations receiving less. Which direction a slope faces makes a tremendous difference in the microclimate—south-facing slopes are hotter and drier than north-facing slopes. Soil type and available nutrients also determine what plants grow in a particular location.

Merriam described the plants and animals as living in broad horizontal bands across the landscape, which he called "life zones." However, where Merriam saw distinct horizontal life zones, other biologists see a blending from one plant community to another. Like a rainbow, from a distance there seem to be distinct, individual colors; but closeup, the gradation from one color to the next becomes apparent. So it is with plant and animal distribution.

The major terrestrial habitats in the Grand Canyon area include boreal forest, ponderosa pine forest, pinyon-juniper woodland, desert, and riparian (streamside) communities. It's interesting to note that three of North America's major deserts meet in the Grand Canyon. On the Tonto Platform grow typical Great Basin Desert shrubs. In the central part of the Canyon along the Colorado River grow Sonoran Desert plants, and in western Grand Canyon species of the Mojave Desert enter.

The Canyon also has unique "hanging gardens" where water seeps out of a cliff. Maidenhair fern, cardinal monkeyflower, Arizona grape, California sawgrass, and the endemic McDougall's flaveria are some of the plants restricted to these gardens.

OPPOSITE: Aspens of the Boreal Forest on the Kaibab Plateau, North Rim. PHOTO © LARRY ULRICH

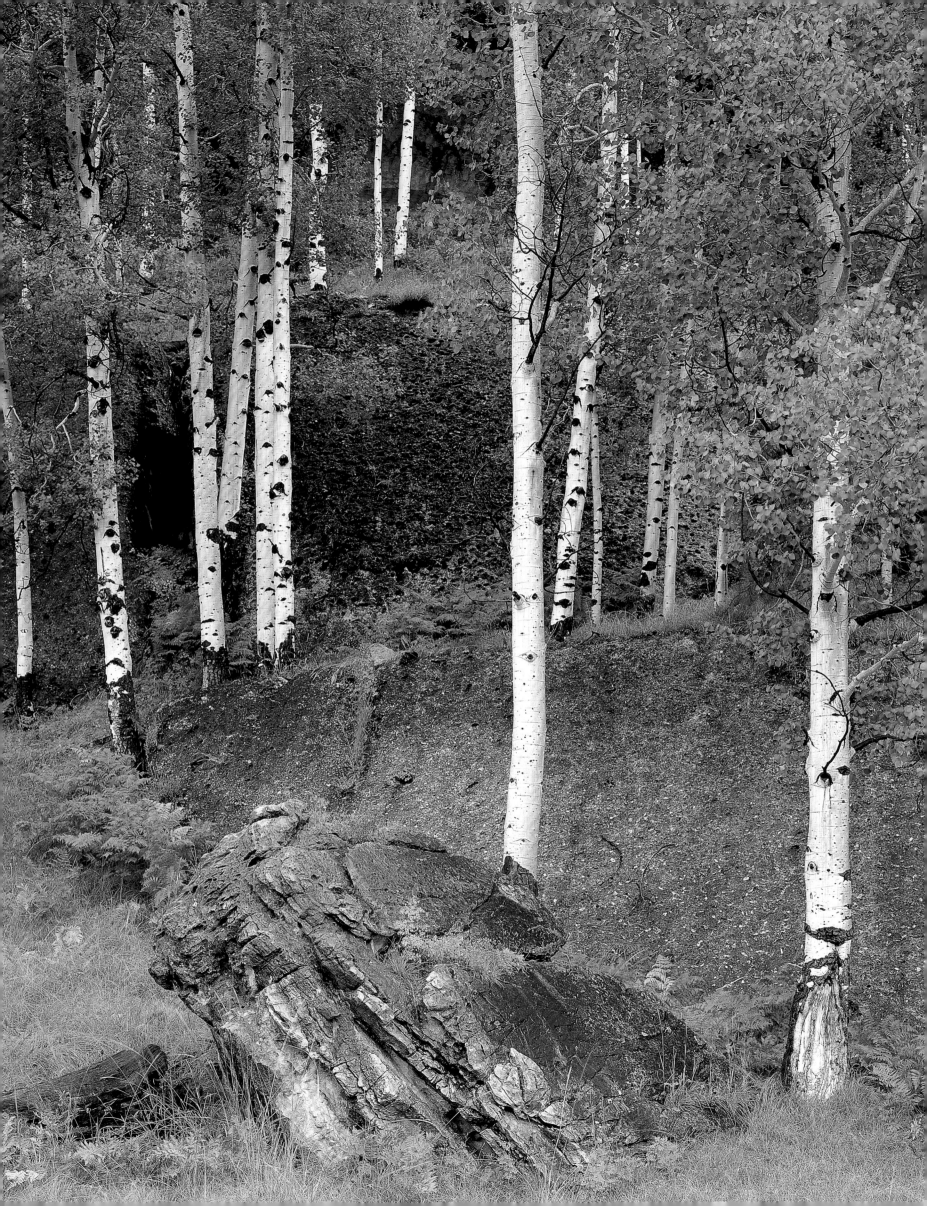

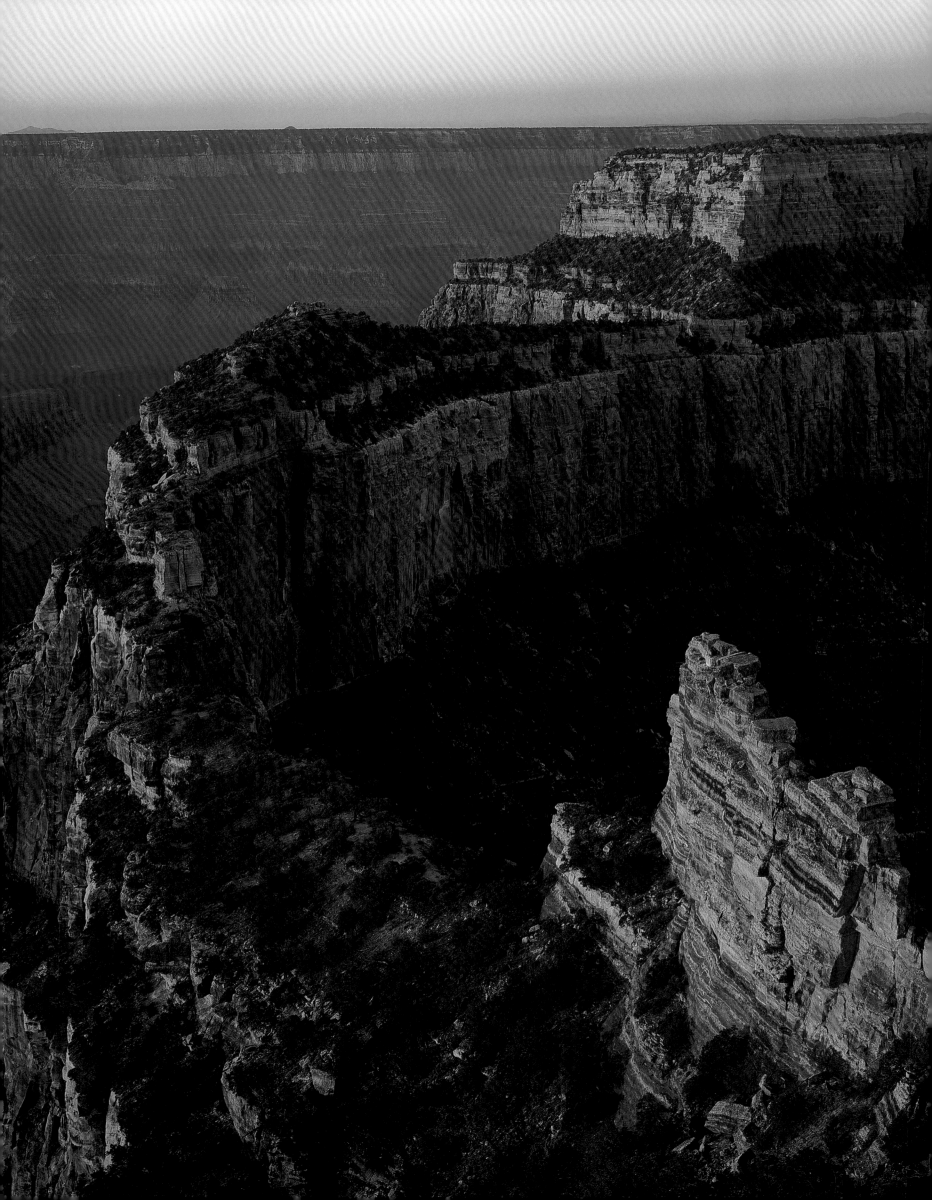

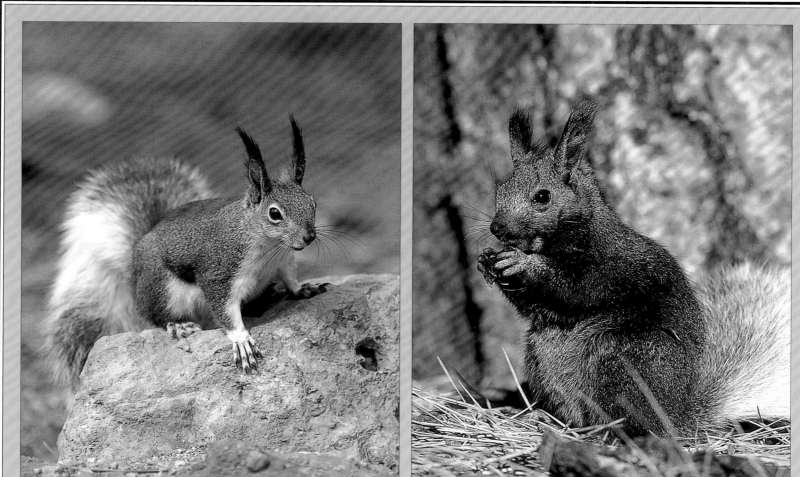

Abert squirrel, South Rim. PHOTO © TOM & PAT LEESON

Kaibab squirrel, North Rim. PHOTO © TOM & PAT LEESON

THE TALE OF TWO SQUIRRELS

A rare treat on the North Rim is to catch a glimpse of the Kaibab squirrel, a unique form of the tassel-eared group of tree squirrels. The Kaibab squirrel has a dark charcoal head and body, rust patch on its back, and a striking snow-white fluffy tail; it is found only on the Kaibab Plateau.

On the South Rim lives the Abert squirrel. It has a gray body with white underparts and gray tail fringed with white. Both tassel-eared squirrels occur only where there is ponderosa pine, depending almost exclusively upon that particular pine for food and nest building. (In the 1970s, the Arizona Game and Fish Department transplanted Kaibab squirrels to the limited pine forests of the Uinkaret Mountains on the Arizona Strip.)

The isolated population of uniquely colored Kaibab squirrels is an excellent example of what biologists call insular evolution. Islands, whether they be in the middle of the sea or a biologically isolated land habitat, often have species that are endemic (restricted) to them. In this case, the "island" is a ponderosa pine forest surrounded by desert.

How did the squirrels get to the Kaibab Plateau? One scenario suggests that before the Grand Canyon existed, the ancestors of these squirrels all lived in one huge intact pine forest. As the Colorado River carved the Grand Canyon, the forest and resident squirrels became separated from each other. Over eons of time, the isolated North Rim population began to exhibit the dark body fur and white tail genes.

The problem with this explanation is one of timing. Ponderosa pine probably did not migrate into northern Arizona (presumably from the south) until a mere 10,000 to 11,000 years ago. The Grand Canyon is at least several million years old. So, how did the pine make its way to the north side and how and when did the squirrel follow? Food for thought. Stay tuned for answers.

One thing known for certain is the important role these squirrels play in the health of the ponderosa forests. Interwoven around the roots of the pines are specialized fungi. The fungi absorb water and minerals from the soil and produce growth stimulants, all of which are absorbed by the tree. The pine photosynthesizes sugars for itself and the fungi, a beautiful symbiotic relationship. The fungi produce underground fruiting bodies called false truffles. But, how do its spores get spread around to new pine seedlings? That's where the squirrels fit in. Using their noses, they locate the false truffles (even under a foot of snow), dig them up, and eat them with relish. Later, the squirrels defecate on the run, spreading fungal spores through the forest.

OPPOSITE: Sunrise light on Wotans Throne, Cape Royal, North Rim. PHOTO © LEWIS KEMPER

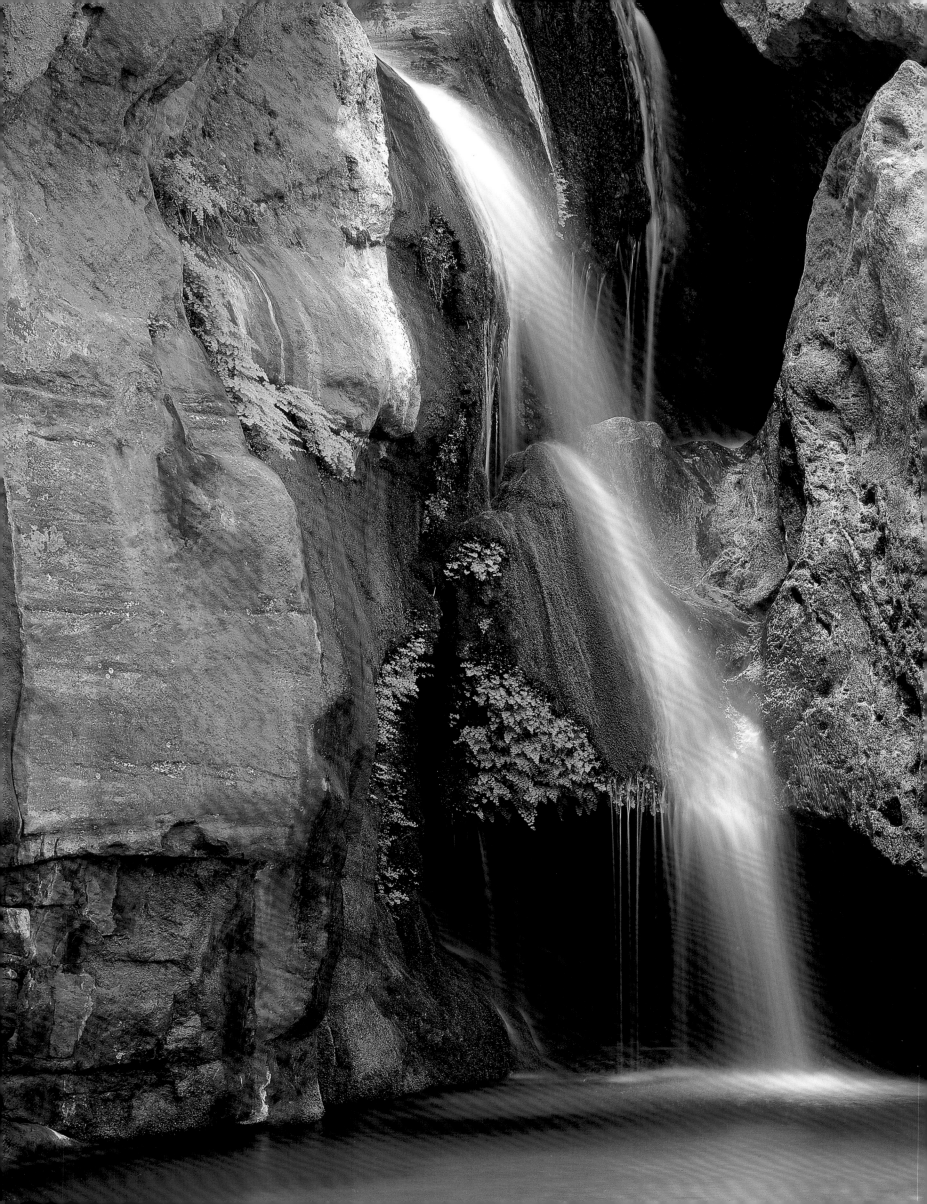

Below THE RIM:

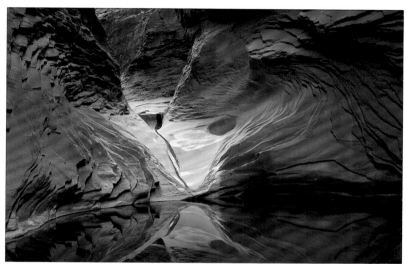

Water-sculpted crossbedded sandstone in North Wash. PHOTO © RANDY PRENTICE

Before I drifted off to sleep in the depths of Boucher Canyon, I studied the alley of sparkling stars above me—spring constellations were rising above the canyon wall and the fuzzy smear of the Milky Way stretched from rim to rim. Way off, a poorwill called his name; closer, a great horned owl hooted. A canyon mouse scampered across my pack, pausing briefly, whiskers twitching, dark eyes flashing in my candle lantern's light. A sphinx moth, hovering like a hummingbird, poked its long proboscis into the white, trumpet-shaped flower of a jimson weed. Faintly, I could hear the click, click, of a bat echolocating for insects. I blew out the candle.

Just before dawn, I felt cold drops of water splash on my face. Without opening an eye, I reached out and grabbed the edge of my tarp and rolled up like a burrito. But soon a rivulet of water ran down inside my nest.

"Okay, you win," I shouted to the silent canyon walls; a mocking echo returned. I hurriedly stuffed my gear into my backpack and scrambled up a slope to an overhang of Tapeats Sandstone. The ledge was festooned with the casts of hundreds of marine worm burrows, testimony to a sea that was here half a billion years ago.

Sunrise was breaking, and in the soft gray light I fired up the stove and brewed some java. As morning brightened, clouds swirled off the rims and veiled the Tower of Ra. The rain continued like a Scottish Highland mist, but this was no land of heather and moors. These crags bristled with blackbrush, yucca, and cactus.

After breakfast, the sky began to clear and a double rainbow arched across Crystal Creek framing Mencius and Confucius temples. I decided to head for Hermit Canyon. The trail out of Boucher Canyon climbs steeply to a broad, relatively flat (but deceptively undulating) bench known as the Tonto Platform. This plateau, which overlooks the thousand-foot-deep Inner Gorge, extends roughly from Red Canyon on the east to Garnet Canyon on the west. A corresponding feature exists on the north side of the river as well. An ancient trail maintained by use traverses the south platform and allows hikers to connect various rim-to-river trails. It's called the Tonto Trail. The name, which is Spanish for

foolish, derogatorily refers to a band of Apaches who probably were never even close to the Canyon. The Tonto can make fools out of hikers. At times, it meanders endlessly in and out of each side canyon covering many miles to go one mile in a straight line. On the other hand, the trail offers great, expansive views and acrophobic vistas down into the Inner Gorge and the mighty Colorado River.

The rain had washed the desert to life. While plants have their stomata, or pores, open to "breathe in" carbon dioxide, terpenes and other vapors escape and scent the moist air with a wonderful fresh fragrance. Cacti only open their stomata at night to reduce desiccation. Carbon dioxide is stored as organic acids which are then used during photosynthesis during the day.

Under the ubiquitous blackbrush is green moss and microbiotic crust, a delicate blackish layer of lichens, algae, and fungi that helps bind the friable soil. There I spotted the shell of the land snail *Oreohelix*. In the geologic past, when the region was wetter, snails and their kin could move about more freely without much concern about becoming escargot jerky. But over the last 11,000 years, the American Southwest has warmed up and dried out; mollusk populations became separated from each other allowing, new species to evolve.

Where the Tonto Trail crosses Travertine Canyon, I saw more evidence of moist past times. Large mounds and ledges of travertine reveal that long ago springs burst forth from the cliffs above with highly mineralized water. The calcium carbonate (limestone) precipitated out to form the travertine. Today the springs are dry.

Looking up, I spied two desert bighorn rams making their way up the pistachio-green Bright Angel Shale slope. They stopped and gave me a good stare. When these wild sheep get above you, they apparently feel less threatened and may quit retreating. The silent moment was suddenly shattered by the *whomp, whomp, whomp* of a helicopter, followed by another, and another, and then by a small plane. The air tour companies advertise that their craft intrude on the Canyon's quiet for only a few seconds, but what they don't mention is that there are over 80,000

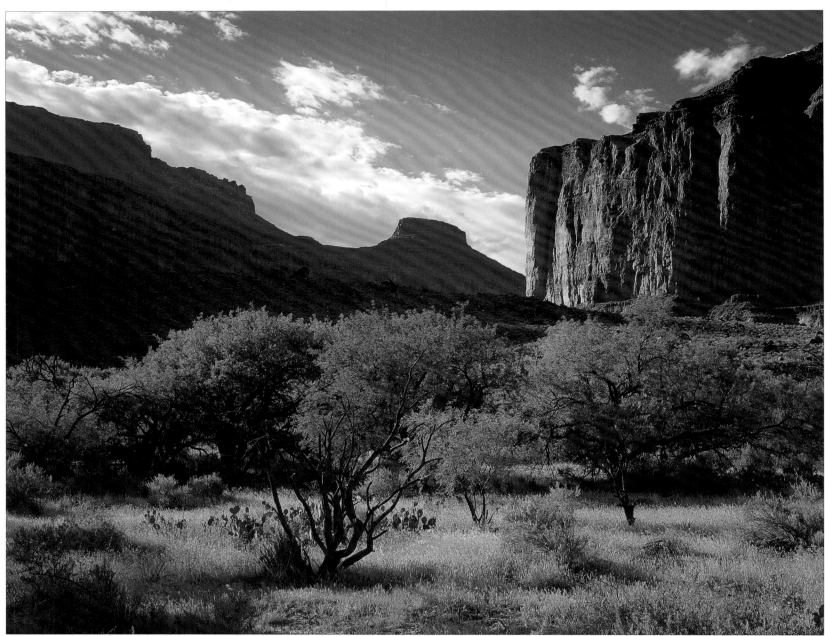

Grove of mesquite trees near the delta of Nankoweap Creek.

scenic flights a year, which add up to a lot of seconds. I looked back toward the slope, but the sheep were gone.

By late afternoon, I had ascended more than 2,000 feet to the top of the Supai Group, a collection of red sandstone and shales. Here the trail snakes along a thin edge of sandstone overhanging a gorge. Ravens glide at eye level, and a flock of noisy pinyon jays swoops by, but my attention is focused on my feet.

Scattered blackbrush still grow here, joined by Mormon tea, sagebrush, mountain mahogany, narrowleaf yucca, scrub oak, pinyon, and juniper. At the edge of the trail is a seastar-like organism. Closer examination shows it to be an earthstar (*Astreus hygrometricus*), a modified puffball fungi. Even in dry years, this species will fruit in these poor soils. One more strange and wonderful resident living in a strange and wonderful place, this world below the rim.

Beavertail cactus, Hermit Creek.

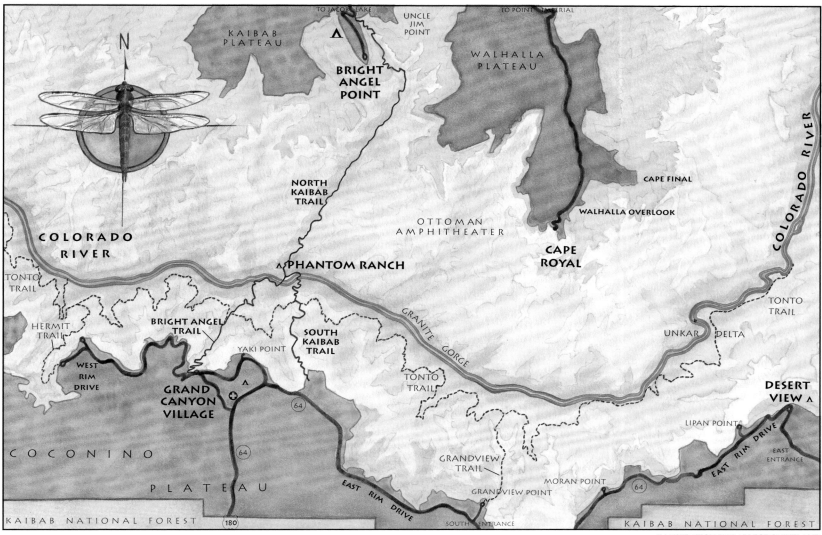

ILLUSTRATION BY DARLECE CLEVELAND

Renowned Canyon hiker Harvey Butchart succinctly warns, "The Grand Canyon is not the place for one's first experience in hiking." A Grand Canyon hike is like mountain climbing in reverse. The trailheads are at high elevation (6,000 feet or more) and the trails, of course, go down. Then when you are tired, blistered, and dusty, the hardest part of the trip, the climb out, is ahead of you. Safely assume that the uphill portion of your hike will take about twice as long as the descent.

Furthermore, except for the **Bright Angel**, **North and South Kaibab**, and a few short rim trails, none are maintained on a regular basis. Expect steep, sometimes treacherous footing, and lots of loose rocks to sprain your ankle or worse.

During the summer, the inner canyon literally becomes a life-threatening oven. Temperatures can soar to over 115 degrees F. in the shade. Hikers must drink a gallon of water a day or risk heat exhaustion, sunstroke, or death. The Colorado River may look tempting for a refreshing swim, but it may be your last. The water is very cold and the currents deceptively strong. More hikers drown than expire any other way! In the winter, sudden blizzards can bury the upper reaches of the trails or cover them with ice. Hypothermia, the dangerous lowering of one's body core temperature, and frostbite are possible.

Weatherwise, spring and fall are probably the best times to hike in the Canyon. Even then, the importance of carrying adequate water cannot be overemphasized. Except for piped water in campgrounds, all water sources—springs, creeks, and the Colorado—should be treated.

Also, protect your food. During the day, aggressive rock squirrels can chew through packs to reach food. Hang your food at night to keep it safe from mice, wood rats, ringtails, and deer.

From the South Rim, two maintained trails lead to the river—the **Bright Angel** (10.3 miles to Bright Angel Campground) and **South Kaibab** (6.4 miles to the Bright Angel Campground). The **Hermit Trail** (8.9 miles to the river) and the **Grandview Trail** (3.0 miles to Horseshoe Mesa) are good introductions to the more primitive routes into the Canyon.

Only one maintained trail descends from the North Rim, the 14.2-mile **North Kaibab**. Combining this with the **Bright Angel** or **South Kaibab** trails allows a cross-canyon adventure.

A permit is required for all overnight backpacking. Get a copy of the park's *Backcountry Trip Planner* for more information. For a hassle-free backpack, the Grand Canyon Field Institute offers educational, guided trips into the Canyon. Other ways to get below the rim include mule rides and river trips.

PAGE 40/41: *Cottonwood and Havasu Falls, morning along Havasu Creek, Havasupai Indian Reservation.* PHOTO © GARY LADD

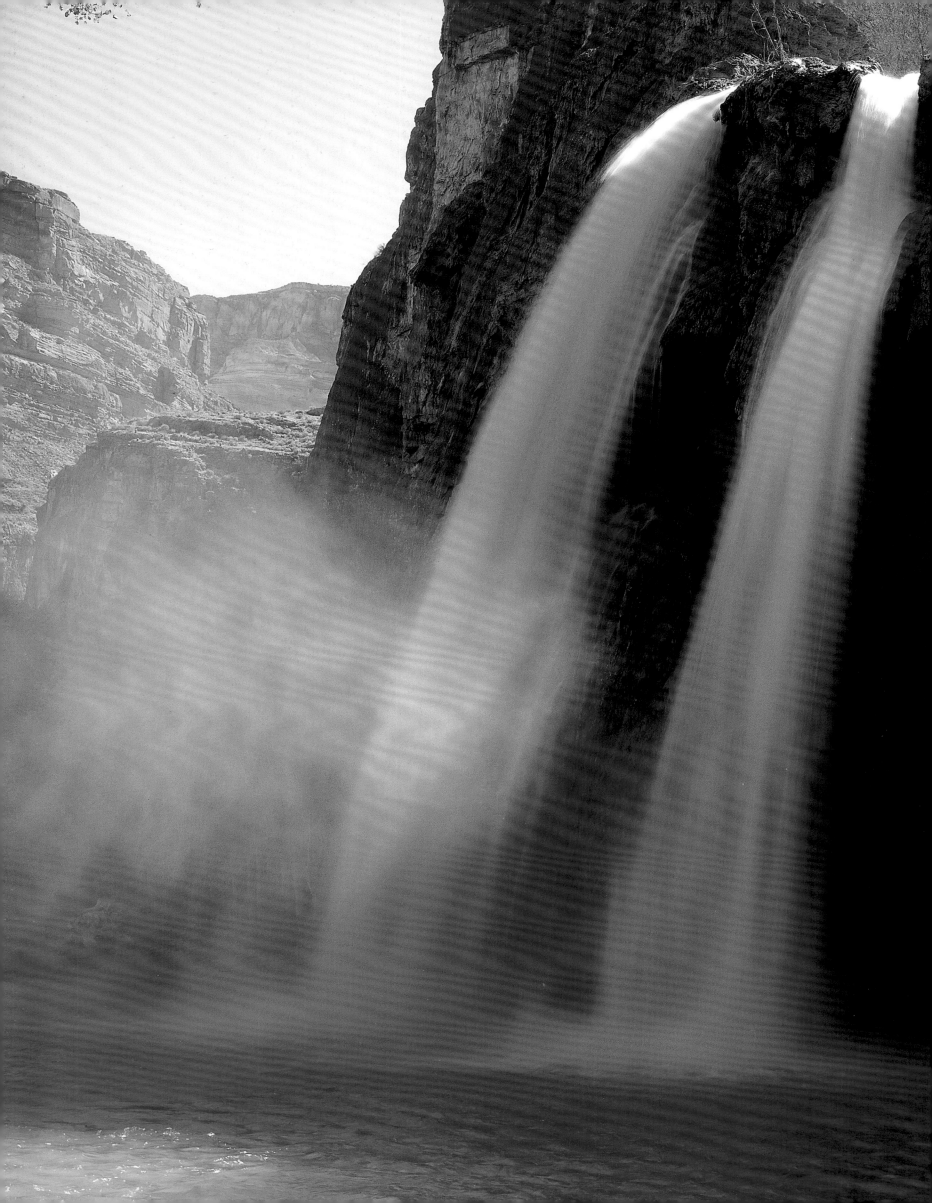

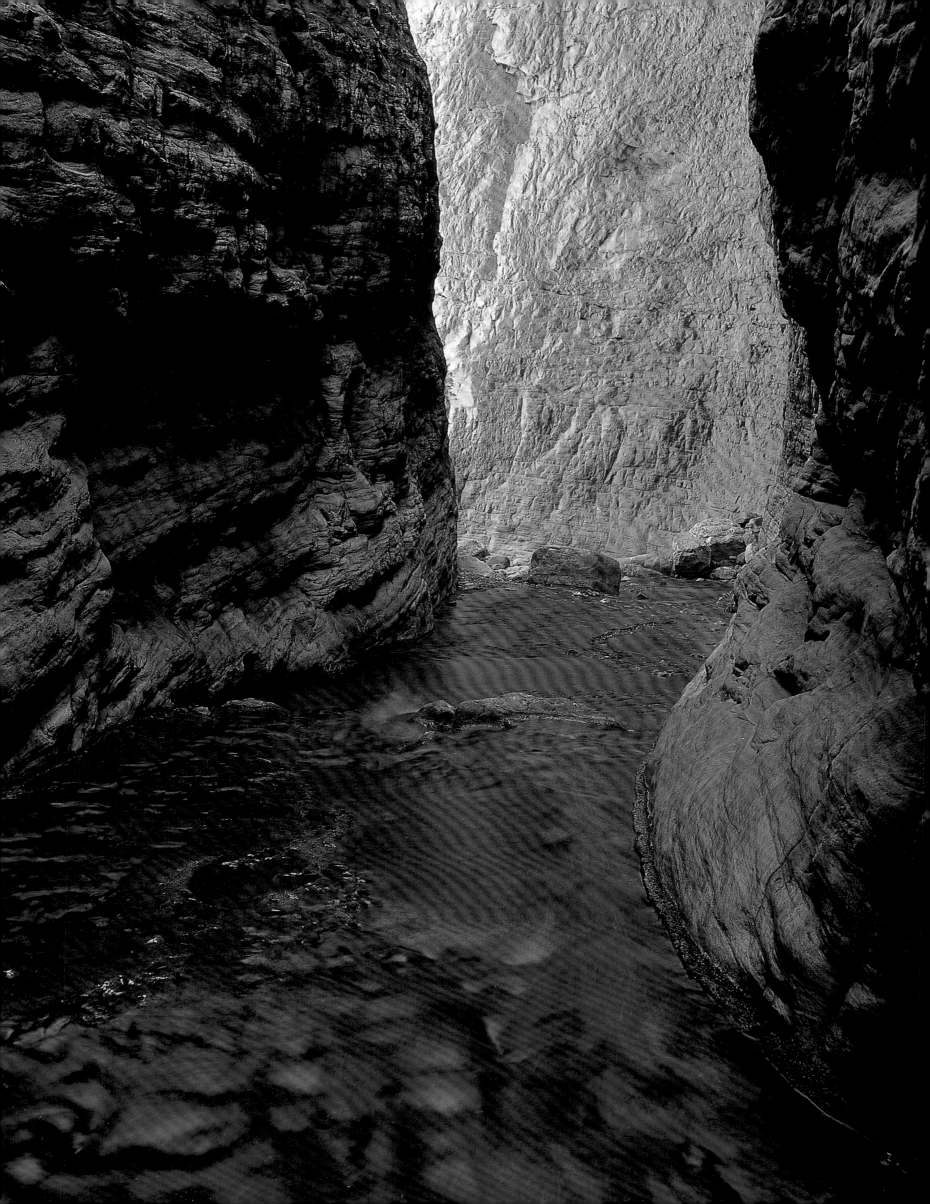

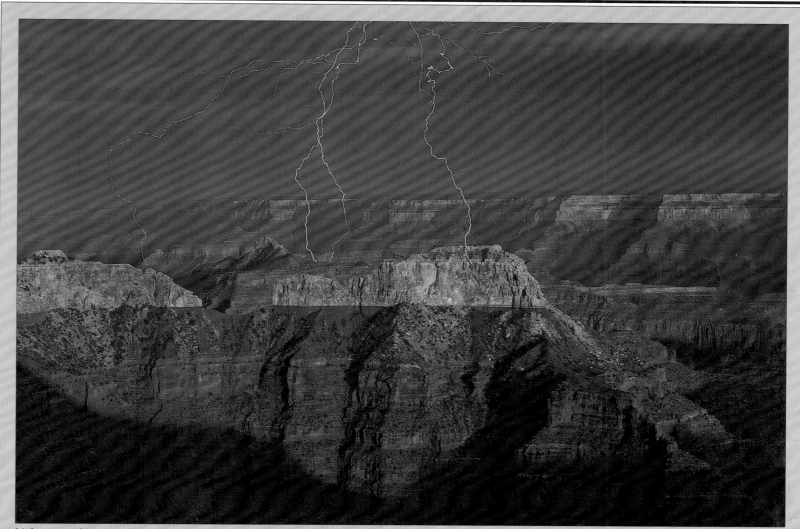

Lightning striking temples and buttes of the North Rim seen from Point Sublime.

PHOTO © DICK DIETRICH

WEATHER

As a general rule, the temperature rises as one descends into the Canyon. (The rule of thumb: every thousand feet of loss equals three to five degrees Fahrenheit increase.) On a midsummer afternoon, the North Rim's Grand Canyon Lodge (8,300 feet elevation) may be recording 85 degrees F. whereas Phantom Ranch (2,400 feet elevation) is baking at 115 in the shade four feet off the ground. And in winter, as rim snows drift against orange-barked pines, new vibrant green grass may be coming up along Bright Angel Creek.

Spring can be variable as winter attempts to keep its icy grip by surprising visitors with an occasional late snow flurry. Early summer tends to be dry, but July and August days are routinely punctuated by daily thundershowers. The morning begins clear, the sky flawlessly blue. As the day heats up, convection currents lift humid air, coming north from Mexico, high into the troposphere. The moisture condenses as towering cumulonimbus. Suddenly a streak of lightning bolts from cloud to canyon butte. A peal of thunder rumbles and reverberates off the walls. Dark curtains of plump raindrops, and sometimes hail, drench a few places but miss most. Often the rain evaporates, a virga shower, before reaching the bottom of the inner canyon. The rain cools the air and the clouds begin to dissipate. Late afternoon is again clear and refreshing. The desert has been cleansed.

This summer rainy period is called the summer monsoons. The moisture is the result of a relatively stable high pressure system over the Gulf of Mexico that pumps humid air into Mexico and the American Southwest. Lightning is prevalent during these storms, so be very careful, especially out on the Canyon rim.

Fall is marked by dry, sparkling days and cold starry nights. A favorite time to hike in the Canyon.

Sometimes by Halloween or more likely by Thanksgiving, winter returns. Pacific-generated lows sweep across the Southwest. The higher parts of the North Rim may receive over 150 inches of snow. On the 1,500-foot-lower South Rim, half as much snow falls. Rarely do the winter storms close the roads for more than a day, and the hotels and other tourist facilities stay open. The high altitude, with its low barometric pressure and intense sunlight, allows much of the snow to sublimate, never going through the liquid state. Thus paved roads clear rapidly.

OPPOSITE: Glowing walls above Stone Creek. PHOTO © FRED HIRSCHMANN

Vishnu Temple, early morning. PHOTO © TOM TILL

Deva, Brahma & Zoroaster Temples. PHOTO © JEFF GNASS

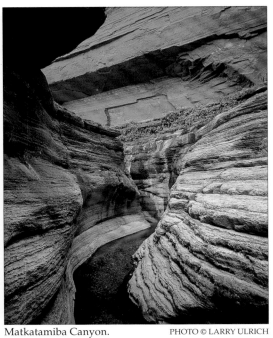

Matkatamiba Canyon. PHOTO © LARRY ULRICH

Native Americans favor descriptive names for the geographic features around them. To the Havasupai the Grand Canyon is known as *Chicamimi Hackatai* (large canyon with the roaring sound) or *Wikatata* (rough rim). To the Paiute, it is *Pahaweap* (water deep down in the earth or a long way down to water).

The first Europeans to see the Canyon were a small group of Spanish soldiers connected with the Coronado Expedition of 1540, searching for the legendary Seven Cities of Cíbola. Pedro de Castañada recorded it as *barrancas*, Spanish for cliffs. Another soldier referred to the river simply as an *arroyo*, a gutter or small stream. The year before, another Spaniard, Francisco de Ulloa, had sailed to the head of the Gulf of California and encountered the mouth of the Colorado River but gave it no name.

In 1604, Juan de Oñate, governor of New Mexico, called the river *Río Grande de Buena Esperanza* (big river of good hope) while viewing it near its confluence with the Bill Williams River in west-central Arizona. He apparently was the first to coin the term *Río Colorado* (red river), but applied it to the muddy Little Colorado River. Spaniard Juan Manje may have been the first to use the name Colorado for the main stem, but not until 1774 did Fray Francisco Tomás Garcés, a Franciscan padre, consistently refer to the main river as the Río Colorado.

Two years later, Garcés visited the Hualapai, Havasupai, and Hopi Indians. Along the way, he viewed the Grand Canyon probably from near Grandview. He remarked how the Canyon was like a prison but to the northeast it opened up like a pass which he called the *Puerto de Bucareli*, named after the viceroy of New Spain. The current usage of the Spanish word *cañon* would not occur for another century.

In 1857, Lieutenant Joseph Christmas Ives called it the Big Cañon. The following year, an anonymous editor added the name Grand Canyon to an introduction to Ives' report. The name Grand Canyon also appears on an 1868 railroad survey map prepared by General William Palmer. But it is John Wesley Powell who is credited with promoting the name Grand Canyon.

As prospectors, engineers, scientists, and map makers explored the Canyon, they named many of its features. Powell and his crew christened Bright Angel Creek in contrast to the Dirty Devil River, Surprise Valley for obvious reasons, Vasey's Paradise in honor of a botanist friend. Railroad surveyor Robert Brewster Stanton commemorated crew member Peter Hansbrough's drowning with Point Hansbrough. Geologist Clarence Dutton's love of architectural terms and Eastern religions led to Brahma, Budda, and Shiva temples, Hindu Amphitheater, the Palisades, Vishnu Creek, and Zoroaster Canyon. Topographers François Matthes and Richard Evans bestowed mythical, classical, and religious names such as Apollo Temple, Krishna Shrine, Excalibur, Guinevere Castle, Lancelot Point, and Walhalla Plateau. Early resident and prospector William Wallace Bass thought of Copper Canyon, Garnet Canyon, and Serpentine Canyon.

Contemporary river runners have also baptized topographic features with secular appellations like Christmas Tree Cave, Furnace Flats, Nixon Rock (you have to row right of it), Six Pack Eddy, and Rancid Tuna Fish Sandwich Rock.

Surprisingly, Teddy Roosevelt, staunch supporter of making the Canyon a national park, did not have any feature named for him until July 3, 1996, when Roosevelt Point was designated on the North Rim.

OPPOSITE: Isis Temple, sunrise. PHOTO © ERIC WUNROW

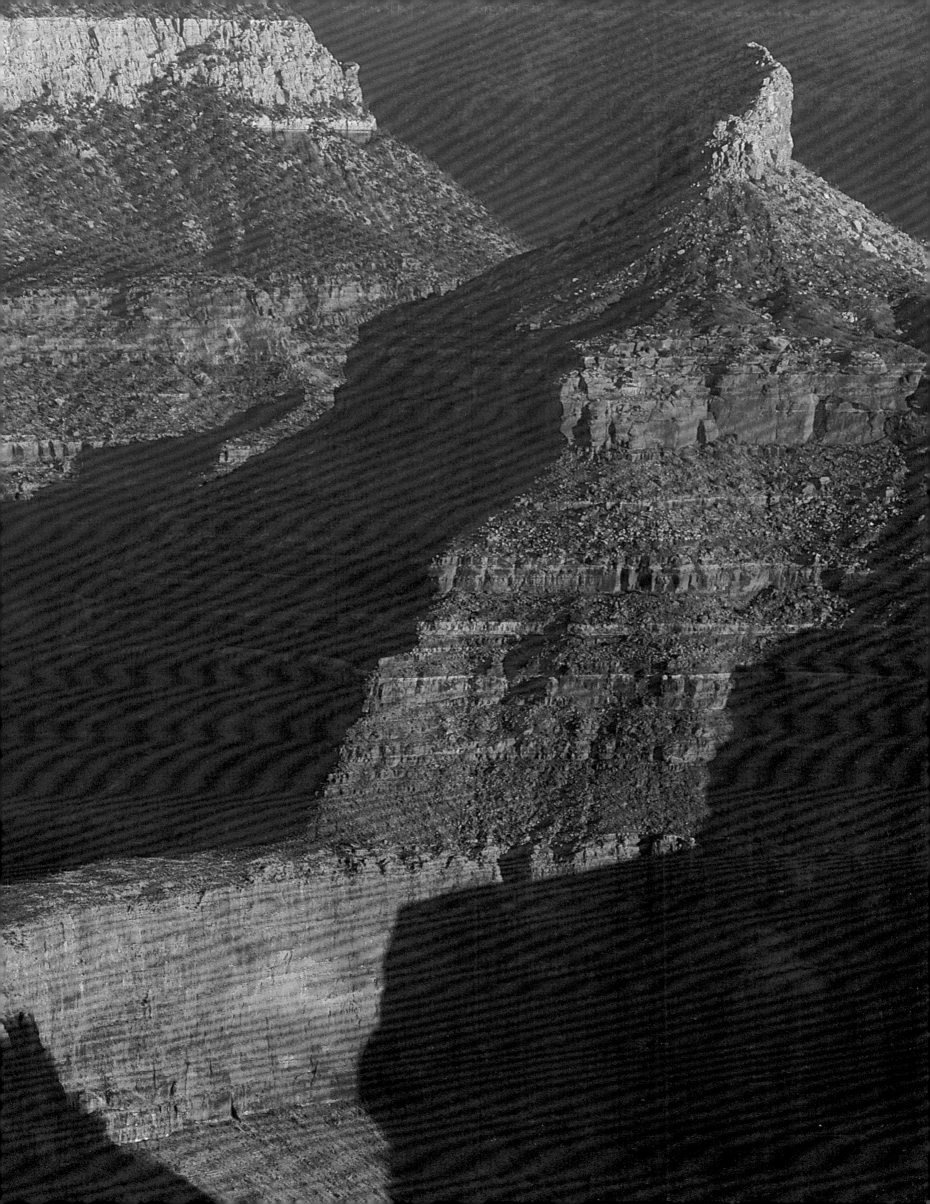

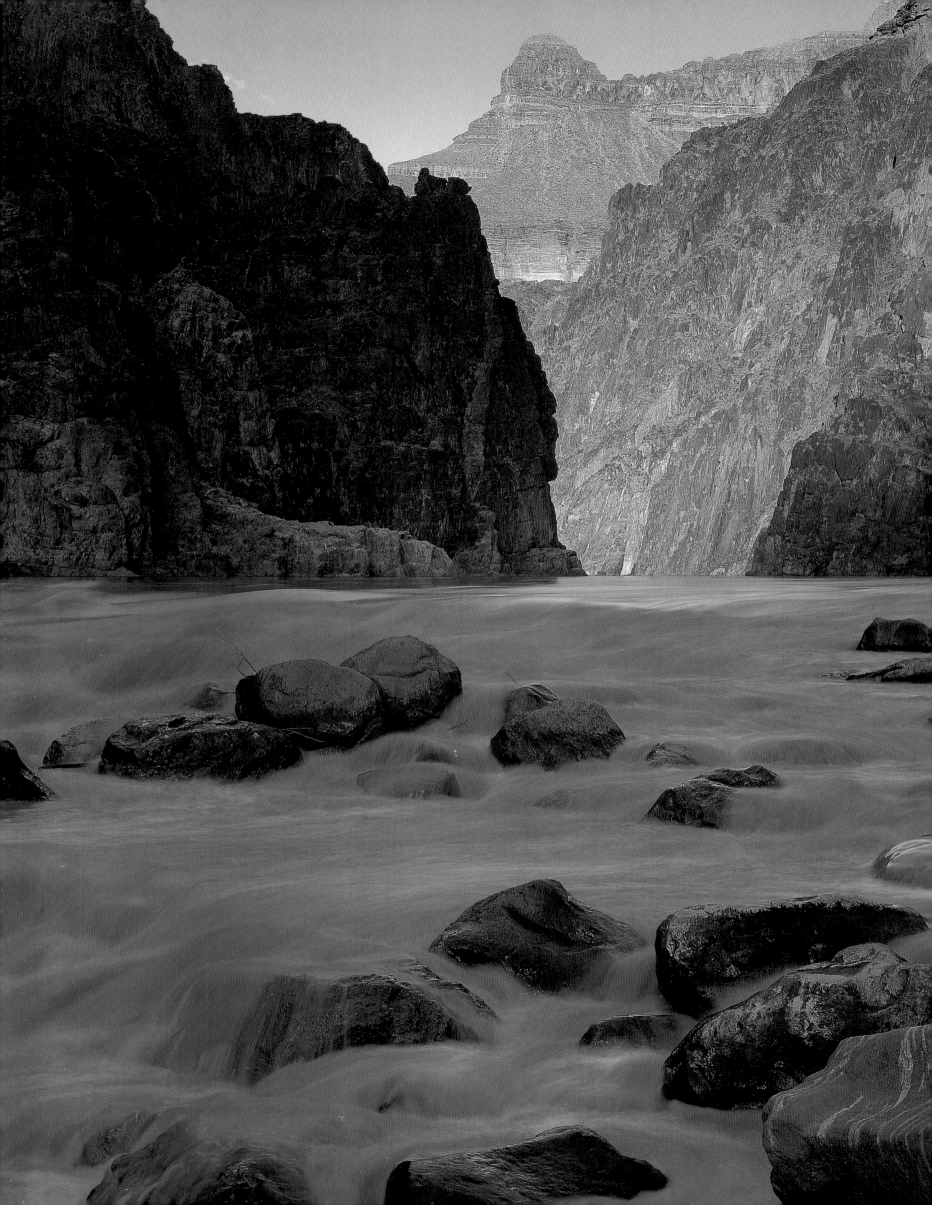

The RIVER:

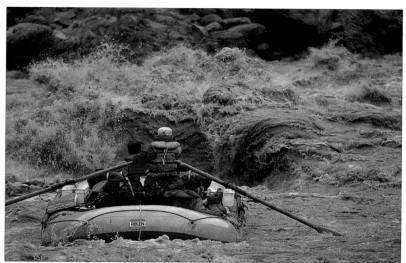

Rafters entering Crystal Rapid. PHOTO © MARY ALLEN

Our raft drifted slowly toward the maelstrom known as Horn Creek Rapid. Don was just learning how to maneuver this oar-powered, catamaran-style behemoth. He sat high, toward the stern, a heavy oar in each hand. Crouched behind him was Peter, an extraordinary river rat and our whitewater instructor. We floated imperceptibly toward the grumbling rapid.

Although the Colorado River within the Grand Canyon drops 2,000 feet through 160 major rapids and is considered one of the premier whitewater adventures in North America, I have always loved best those tranquil, lakelike stretches that separate the brief moments of aquatic chaos. Flash floods and debris flows have dumped tons of boulders from steep side canyons into the main stream that the Colorado can't always remove—thus a rapid is born. These obstructions cause the river to pool upstream creating not only a serene, calm respite but also upstream currents that often require the boatman to row the raft right to the brink, all the while anxiously glancing over his shoulder.

We were getting closer to the tongue, that V-shaped, smooth slick of water leading into the guts of the rapid. Our ponderous craft was perpendicular to the current, a position allowing for easier last-second alignment.

"Push on the both oars Don," Peter said quietly, "Okay, that's hard enough."

"Get ready to pull on the left oar while pushing the right."

This maneuver would swing the raft ninety degrees so the bow would point straight downstream. The oars could then be used like brakes to slow our momentum or ferry us away from a dangerous rock or hole, a technique first employed by mountain man Nathaniel Galloway during his 1897 trip down the Colorado.

"Okay, Don. Pull and push." Precious seconds slipped by.

"Don. Turn Don," Peter betrayed no apprehension, no fear.

I tightened my grip.

The roar of the tumbling, crashing water was deafening. Don's eyes were as big as saucers. Raw, stark fear contorted his face. His arms were frozen in place.

"Don, turn the boat Don. Too late Don," came a gentle voice

above the river's roar.

Over the top we dropped, still sideways. The downstream tube sank like an anchor, the upstream tube breached like a whale. A deluge of icy water swept over us. My knuckles went white and the sudden chill made me gasp, but instead of air I sucked in water. My God, we're going over!

Following John Wesley Powell's successful 1869 journey down the Colorado River through the Grand Canyon, only a few brave men and women would challenge the rapids over the next one hundred years. Two of these people were honeymooners, Glen and Bessie Hyde. In 1928 they plied the river in their homemade scow, got at least as far as 232 Mile Rapid in western Grand Canyon, then vanished. Their boat was found upright still containing their gear, including Bessie's cryptic diary.

The first women to survive a river trip were two botanists, Elzada Clover and Lois Jotter, who accompanied Norman Nevills on his 1938 run. Nevills would eventually be the first to offer commercial trips through the Canyon. Beginning in the 1950s, Georgie Clark White revolutionized river running by building huge rafts out of army surplus bridge pontoons. Her motorized G-rigs made the trip safer and more appealing to novices. And Georgie's leopard-print bathing suits became legendary.

Yet up until 1964, fewer than a thousand people in total had gone down the river. Astonishingly, by 1972 more than 16,000 were enjoying the adventure each year. This sudden dramatic increase in river runners alarmed the park service. Studies were begun to examine the possible ecological impacts and ways to mitigate those problems. Not far into their study, the scientists realized that Glen Canyon Dam, completed in 1963 upstream of the Grand Canyon, was also playing havoc with the river's ecosystem.

The river that was once, "too thick to drink, but to thin to plow" was turned into a clear, cold stream. The annual spring floods that laid in new sandy beaches and scoured away riverside vegetation were history. Native fish were replaced with exotic rainbow trout. Plants, some native, some not, invaded the river banks, establishing a new riparian habitat that has allowed certain

OPPOSITE: Dana Butte towers above Granite Rapid, Inner Gorge. PHOTO © TOM TILL

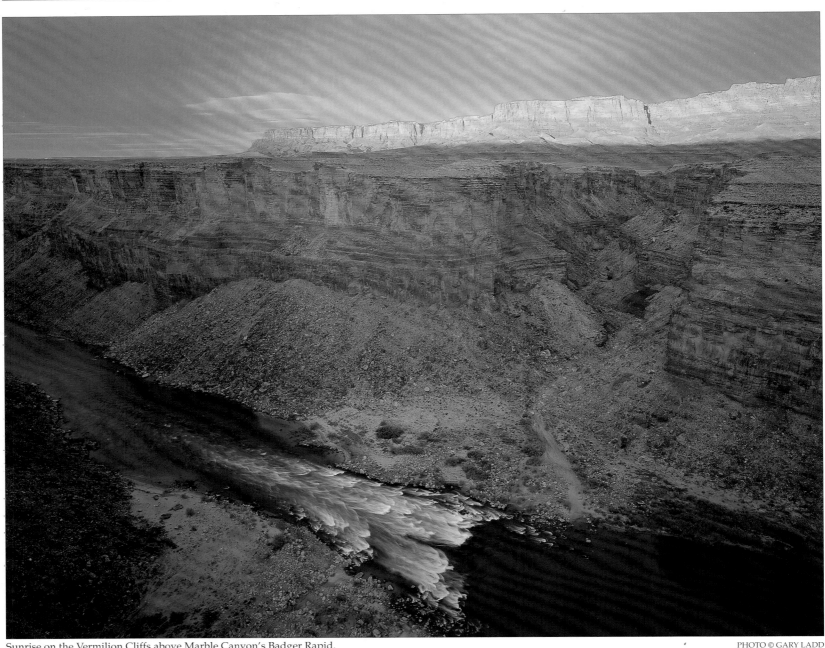

Sunrise on the Vermilion Cliffs above Marble Canyon's Badger Rapid. PHOTO © GARY LADD

indigenous animals to flourish and has changed the migratory behavior of others. The threatened willow flycatcher nests in the exotic salt cedar along with the formerly uncommon Bell's vireo. Paradoxically, the yellow-billed cuckoo, another riparian-dependent bird, has not been seen since 1971. Dozens of bald eagles now overwinter by feeding on the introduced trout.

Today more than 20,000 people a year enjoy river trips through the Canyon. All trash and human waste is carried out. In 1992, Congress passed the Grand Canyon Protection Act which mandates that Glen Canyon Dam be operated to minimize any detrimental impacts to native plants and animals.

Back at Horn Creek, after what seemed an eternity, but was really only seconds, we exploded out of the waves and into the relative quiet of an eddy below the rapid. We were alive! We were still in the boat! Don looked shell-shocked, but Peter just shook his head. What a ride! We had cheated death once again. Footnote: Don returned to a terrestrial lifestyle.

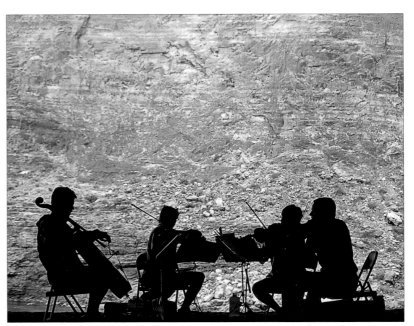

The Beau Quartet—a recital in Redwall Cavern. PHOTO © CHARLY HEAVENRICH

48

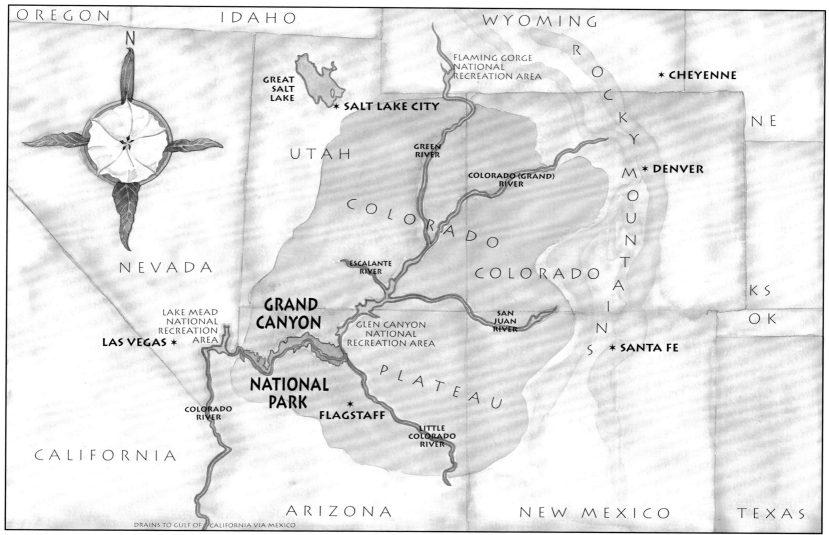

ILLUSTRATION BY DARLECE CLEVELAND

From the Rocky Mountain continental spine and draining an area the size of France, the **Colorado River** writhes 1,450 miles to the sea. Well, almost to the sea. Today the river is usually dry a few miles south of the U.S.-Mexico border. Dammed, diverted, evaporated—all used up.

A hundred years ago, the free-flowing waters of the **Green River** and the **Grand River** flowed together to form the Colorado deep in the heart of what is now Canyonlands National Park in east-central Utah. Then in 1921, the state of Colorado convinced Congress to officially change the name of the Grand to the **Colorado River**. The older name still lingers as Grand Lake, Grand Junction, and Grand Mesa. The **Green River** at 730 miles is the longer tributary and contributes about two-thirds of the Colorado's volume; so hydrologically the Green probably should have earned the name Colorado. But politics overshadowed science and logic.

Large-scale regulation of the river began with the 1922 **Colorado River** Compact which divided seven western states—Wyoming, Utah, Colorado, New Mexico, Arizona, Nevada, and California—into upper and lower basins with Lees Ferry the designated dividing point. The compact allocated 7.5 million acre-feet of water annually to each basin (one acre-foot is the amount of water that covers an acre to one foot in depth). A 1944 treaty also guaranteed Mexico 1.5 million acre-feet each year. However, since 1930 the Colorado's annual flow has only averaged 14 million acre-feet. Evaporation from reservoirs removes another 2 million acre-feet, resulting in a shortfall of 4.5 million acre-feet. Today, various Indian tribes that were not included in the 1922 compact are seeking to acquire their "fair share" of the Colorado, too.

There simply is not enough water to go around. Explorer and geologist John Wesley Powell understood this. He called for organized development of the Southwest that was based upon the location of the limited amount of water. But few listened.

The first large dam placed on the Colorado was Hoover, originally named Boulder Dam and completed in 1935. Its reservoir, Lake Mead, backs more than 40 miles into the lower Grand Canyon. The last major dam was Glen Canyon, completed in 1963, just fifteen river miles upstream from Lees Ferry. During the 1960s, two additional dams were proposed within the Canyon—one about 30 miles downstream from Lees Ferry and the other in the western Canyon. Currently, neither are politically viable. The Colorado may be the world's most legislated, litigated, and debated river.

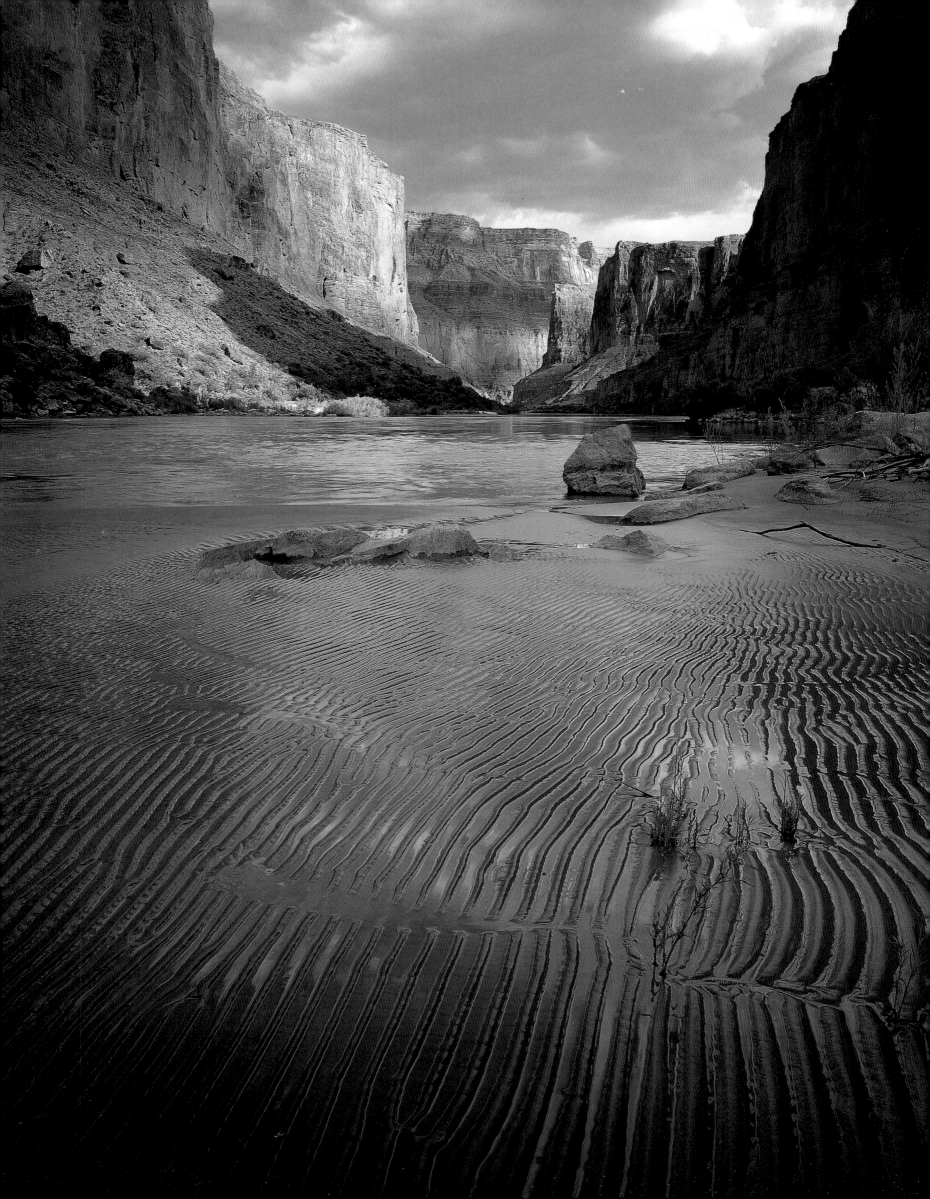

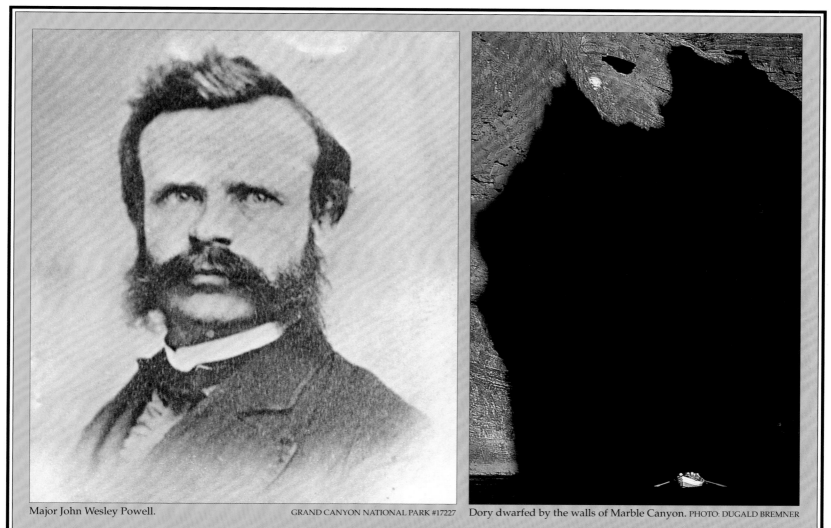

Major John Wesley Powell. GRAND CANYON NATIONAL PARK #17227 Dory dwarfed by the walls of Marble Canyon. PHOTO: DUGALD BREMNER

JOHN WESLEY POWELL

In 1861 an intense, largely self-taught, twenty-seven-year-old public school principal from Illinois joined the Union Army to fight against slavery. The next spring at Shiloh as John Wesley Powell raised his right arm to signal "Fire," a Confederate minié ball shattered the bone, requiring amputation. Undaunted, Powell continued to serve until the end of the Civil War. He then taught courses in botany, zoology, anatomy, entomology, and geology at Illinois Wesleyan University.

The summers of 1867 and 1868 were spent out in the Rockies with his wife, Emma Dean, and a small crew of students and relatives exploring and studying the upper reaches of the Colorado River. Powell hoped to "shed light on the central forces that formed the continent." This goal eventually led to a plan to explore a large blank area on the best maps of the time. He would descend the Green River to its junction with the Grand and continue down the Colorado. He would flesh out the *tierra incognito*.

The nation's first transcontinental railroad had recently been completed, and Powell took advantage of the train to have four wooden boats of his design shipped out to Green River Station, Wyoming Territory. On May 24, 1869, Powell and his nine-man crew of volunteers pushed off into the unknown. Rapids quickly extracted their toll—a boat was lost and one man left near Vernal, Utah. On August 10, they arrived at the mouth of the Little Colorado and the beginning of the "Great Unknown." Little did they realize how difficult the rapids ahead would be. Endless days dragged on and on as the men toiled with the heavy boats, navigating what rapids they could, often lining or carrying the boats around unrunnable cascades. Food was running short and what they had left was moldy.

After three months on the river, they came upon yet another horrendous rapid—this time with no way to walk around. Three men had had enough of the river and of Powell's arrogant, aloof leadership. They hiked out what is now called Separation Canyon and were never seen again. As it turned out, this was about the last bad rapid. The next day, August 30, Powell and the remaining five men emerged from the Grand Canyon at the Grand Wash Cliffs.

Powell's exploits made him a national hero. He would return to the river in 1871-72 better funded and with the previous trip's experience. Powell went on to become a powerful bureaucrat in Washington, D.C., eventually founding and later heading the U.S. Geological Survey and the Smithsonian's Bureau of American Ethnology. He was also a founding member of the National Geographic Society.

OPPOSITE: Rippled beach in Marble Canyon, late-afternoon. PHOTO © GARY LADD

Nomadic hunters, known to archaeologists as Paleolithic hunters, wandered across the Intermountain West at the end of the last ice age, about 11,000 years ago, in search of big game—particularly mammoths but also camels, Harrington's mountain goats, shrub oxen, and Shasta ground sloths. Bones and scat from these beasts have been discovered in the Grand Canyon or nearby, so it is likely that at least a few bands of these early people passed this way. The hunters used the spear-throwing atlatl to bring down the huge mammals. A thousand or so years later, the mammoths were extinct in the Southwest, and giant bison became the main prey.

Over the next several thousand years, a continuing warming and drying climatic trend led to dramatic changes in the Canyon's plant and animal communities. Many of the large ice age mammals went extinct. Remaining herds of big game drifted eastward onto the Great Plains, followed by the Paleolithic hunters. Then a different group of people moved into the area, possibly from the Great Basin.

Unlike their predecessors, this Archaic Culture depended more and more on wild plant foods while hunting deer and bighorn sheep. They used grinding stones to pulverize grasses and other seeds into flour. They carefully crafted baskets, cordage, and nets of hair and vegetable fibers. And because they migrated from place to place frequently, they built only insubstantial brush huts. In western Grand Canyon, an incredible panel of painted ghostlike beings is attributed to these people. They also left enigmatic figurines fashioned from split willow twigs in hard-to-reach caves.

By A.D. 200, several varieties of corn, introduced through trade with people from Mexico, were becoming an important part of their diet. These emerging farmers explored the Canyon for suitable homesites and for bighorn sheep and pinyon pine nuts. By A.D. 700, some stayed and built small cliff houses or occasionally larger pueblos along the rims or within the Canyon. Over the next several centuries more and more people moved into the Canyon. They sowed beans, corn, and squash, perhaps a little cotton. The bow and arrow replaced the atlatl, exquisite pottery was made, and several styles of yucca-fiber sandals were crafted. The farmers living in the eastern portion of the Can-

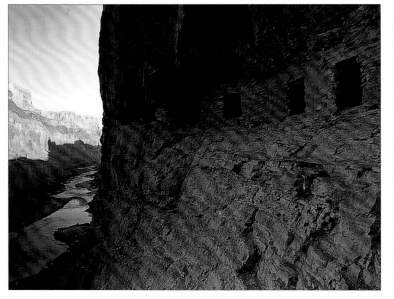

yon are now referred to as the Ancestral Puebloan (Anasazi). To the west and south were the Cohonina.

By A.D. 1130 these farmers had abandoned the area probably because of overuse of the natural resources, overpopulation, and an extended drought. A shift to greater precipitation fifty years later allowed some of these people to return and build settlements along the rim such as Tusayan. But less than a century later, they were gone.

The beginning of the fourteenth century witnessed Cerbat Indians, possibly ancestors of the modern Hualapai and Havasupai, entering the Canyon region from the lower Colorado River valley. They spread as far east as the Little Colorado but stayed primarily on the south side of the Colorado River.

The Cerbat lived in circular brush wickiups; and instead of yucca-fiber sandals, they wore leather moccasins.

About the same time, Southern Paiutes made seasonal trips from the north to the Kaibab Plateau to hunt deer and gather plants. The Paiutes would occasionally cross the Colorado and raid the Cerbats, who would sometimes retaliate. Today, the Kaibab group of the Southern Paiutes have a small reservation north of the Grand Canyon and west of the town of Fredonia.

The Hualapai Reservation stretches along the South Rim in western Grand Canyon; and most of the Havasupai people live in the village of Supai within the depths of Havasu (Cataract) Canyon.

In 1540 Spaniard Garcia López de Cárdenas and his soldiers spent three days looking for a way to the Colorado River below Desert View. Ironically, he had been led here by Hopi who, of course, knew of many ways into the Canyon but were not about to reveal this to the strangers. One old Hopi trail led to a cave where sacred salt was gathered and beyond to a strange spring that marked the *Sipapuni* or place of emergence. Discouraged by the austere country and lack of gold, the Spaniards returned to Mexico.

Not until two centuries later did the next European visit the Grand Canyon. During this hiatus, the first Navajos probably came into the region. The Navajo Nation now abuts the eastern boundary of the park.

On June 20, 1776, Fray Francisco Tomás Garcés entered the "Río Jabesu" (Havasu) Canyon via a wooden ladder fastened to a cliff face. Here he met the Havasupai people who were growing crops along Havasu Creek.

Later that same year, Friars Francisco Atanasio Domínguez and Silvestre Vélez de Escalante almost bumped into the north side

ABOVE: Ancestral Puebloan (Anasazi) granaries near Nankoweap Creek. PHOTO © TOM BEAN

of the Grand Canyon in their search for a way back to Santa Fe from western Utah. All they saw, though, was the head of the Canyon in the Lees Ferry area.

Although still Mexican territory (until 1848), the area was traversed by American trappers in their never-ending quest for more animal pelts. Few of these men left written accounts, but one who did was James Ohio Pattie. Unfortunately, his 1826 dairy is so vague that his exact route in northern Arizona is impossible to trace. Pattie did write of the Canyon and river within as, "these horrid mountains, which so cage it up, as to deprive all human beings of the ability to descend to its banks."

In 1851 trapper-turned-guide Antoine Leroux warned government surveyor Captain Lorenzo Sitgreaves not to follow the Little Colorado River Gorge because of obstacles in the lower reaches. Presumably Leroux was familiar with at least parts of the Grand Canyon. Seven years later, Lieutenant Joseph Christmas Ives descended Peach Springs Canyon and Diamond Creek to the Colorado River. Ives alluded to the Canyon as the gateway to hell, and expedition artist Friedrich W. von Egloffstein reinforced that view with gloomy gothic sketches of the Grand Canyon. Ives predicted, "Ours has been the first, and will doubtless be the last party of whites to visit this profitless locality."

The Ives Expedition then traveled eastward to Havasu Canyon, and portly von Egloffstein started down the same route used eighty-two years earlier by Garcés. While on the ladder, a rung broke and von Egloffstein was "precipitated into the abyss." Unhurt, the artist went on and visited the Havasupai. Upon his return, he was pulled out of the Canyon with gun slings tied together.

In 1869, geologist John Wesley Powell became the first to successfully descend the Colorado River through the Grand Canyon by boat. The following year Mormon missionary Jacob Hamblin and Paiute leader Chuarrumpeak located trails and springs in the Grand Canyon region to help Powell's further scientific studies of the Colorado Plateau (and to aid Mormon settlement).

After Powell became director of the U.S.

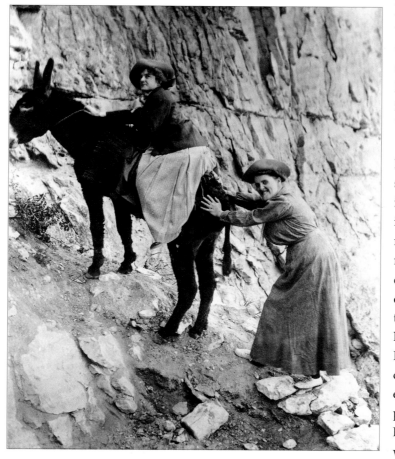

Geological Survey, he sent other geologists to southern Utah and northern Arizona. Clarence Dutton's *Tertiary History of the Grand Cañon District* (1882) is considered the classic geologic report of the region.

The end of the nineteenth century saw ever-increasing exploitation of the Canyon's meager mineral and grazing resources. Tourists arrived at Farlee's Hotel in western Grand Canyon 1883; and the next year, Mrs. Ayer from Flagstaff became the first (non-native American) woman to descend into the central part of the Grand Canyon. Her guide was John Hance, who had come to the Canyon hoping to find gold and silver but discovering more money in the pockets of tourists. One of his guests wrote, "God made the cañon, John Hance the trails. Without the other, neither would be complete."

Hiking in the Canyon simply for pleasure didn't become popular until the 1960s. Probably the most famous hiker is Colin Fletcher, a Welshman, who in 1963 walked from Havasu Canyon east to the Little Colorado, swam across the Colorado, and exited via the old Nankoweap Trail. His epic journey is captivatingly told in *The Man Who Walked Through Time*.

But Fletcher had not set out on his trek trusting blind fate and sturdy legs. He sought out all the information that he could find about inner canyon hiking. He talked to rangers, packers, geologists, and river guides. "But before long, it dawned on me that when it came to extensive hiking in remote parts of the Canyon, none of them really knew what he was talking about. So I set about tracking down the experts on foot travel. In the end I discovered that they totaled one: a math professor at Arizona State College in Flagstaff. But Dr. Harvey Butchart, I was relieved to find, knew exactly what he was talking about."

Butchart had come to Flagstaff in 1945 to begin a teaching career. He hiked in the Grand Canyon and soon set about, as a mathematician would, a systematic exploration of the world below the rim. For the next fifty years, the wiry, indefatigable Butchart hiked and climbed in nearly every corner of the Grand Canyon. He eventually logged more than 12,000 miles and bagged eighty-three of the Canyon's buttes and temples.

ABOVE: Women and mule on Bright Angel Trail (c. 1910). PHOTO BY EMERY KOLB, GRAND CANYON NATIONAL PARK #5433

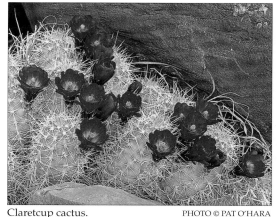

Claretcup cactus. PHOTO © PAT O'HARA

Indian paintbrush. PHOTO © JEFF NICHOLAS

Brittlebush. PHOTO © STEWART AITCHISON

With the Grand Canyon's 8,000-foot elevational range, it's not surprising that more than 1,500 species of plants are known from the area. From April through September, the creamy-white flowers of the cliffrose (*Cowania mexicana*) makes this large shrub conspicuous along the West and East Rim drives and down to the Tonto Platform. It is a favorite browse plant for the numerous mule deer. The shredded bark has been used to make sandals, mats and ropes. Navajo and Hopi fashioned the branches into arrows.

Various species of yucca (*Yucca* spp.) and agave (*Agave* spp.) are found throughout the park. Individual yuccas may flower each year, weather conditions permitting. Agaves, on the other hand, only bloom once in their life. For years, a plant stores carbohydrates in its base and then shoots up a tall stem. The entire plant then dies. Yuccas and agaves provided Indians with fiber, food, soap, and medicine.

In the forest, Indian paintbrush (*Castilleja* spp.) and lupine (*Lupinus* spp.) are two common wildflowers. Paintbrush plants are partially parasitic on other plants. The bright red "petals" are actually bracts that enclose the inconspicuous green flower. There are nine species of lupine in the park. Their distinctive leaf consists of four to eight leaflets radiating out from a single point. The leaflets are slightly folded and collect raindrops or dew which can be an important water source for small animals. Lupines also fix nitrogen into the soil. In late summer, hoary aster (*Aster canescens*) with its numerous violet to purple flowers with yellow centers can be quite common along the rim roads and trails.

Hikers in the Inner Gorge and river runners are likely to notice grayish-green-leafed brittlebushes (*Encelia* spp.) sporting bright yellow flowers from March to June. Brittlebush are browsed by bighorn sheep. The brittle stems, when broken, exude a gum that was chewed by Indians. It is a dominant shrub of the Sonoran Desert of southern Arizona and northern Mexico and reaches its northeasternmost limit along the river in the Grand Canyon.

The relatively cold winters in the Canyon preclude the existence of large cacti like the famous saguaros of southern Arizona, but two dozen small species survive here. These include three prickly pears (*Opuntia* spp.) that are common and usually easy to tell apart. The magenta-flowered beavertail (*Opuntia basilaris*) have no long spines on their pads. Grizzly bear cactus (*Opuntia erinacea*) have a plethora of long, soft-looking spines and pink to rose-colored blossoms. In between these two extremes is the yellow-flowered desert prickly pear (*Opuntia phaeacantha*).

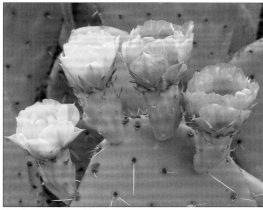

Englemanns prickly pear. PHOTO © LARRY ULRICH

Colorado four o'clock. PHOTO © RANDY PRENTICE

Cardinal monkeyflower. PHOTO © TOM TILL

OPPOSITE: Datura flowers and granite wall. PHOTO © TOM TILL **PAGE 56 & 57:** Colorado River seen from Toroweap Overlook, sunrise. PHOTO © CARR CLIFTON

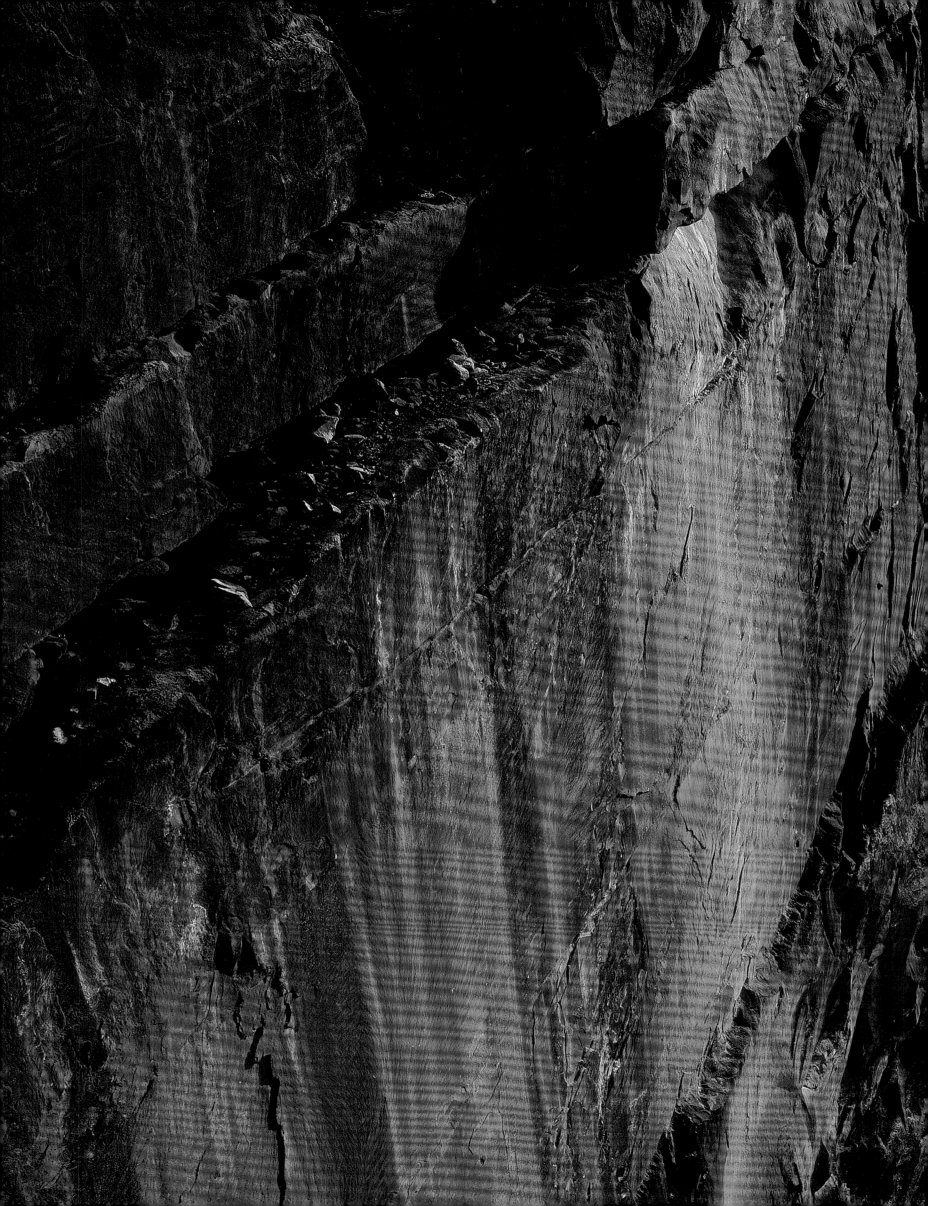

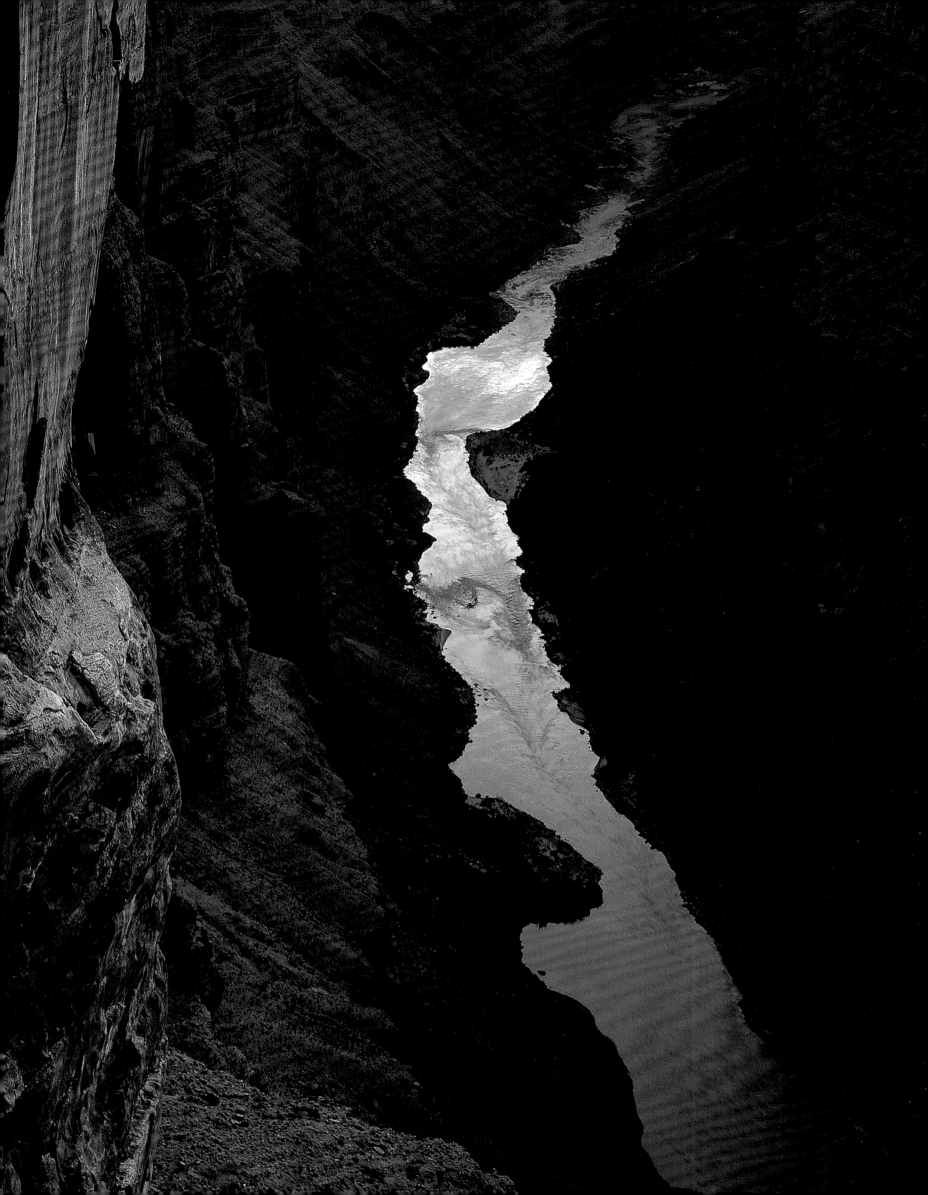

MAMMALS

Coyote. PHOTOS (3) © TOM & PAT LEESON

Mule deer buck.

Golden-mantled ground squirrel.

There are seventy-six species of mammals known to occur in the Canyon area. One of the most commonly seen is the rock squirrel (*Spermophilus variegatus*). Unlike the Abert and Kaibab, this squirrel is primarily a ground dweller. Its sharp trembling whistle is often mistaken for a bird call. Where people feed rock squirrels, they can become quite abundant and aggressive. They can bite and may carry plague or other diseases.

Within the park are three kinds of chipmunks, plus the slightly larger but similar looking golden-mantled ground squirrel (*Spermophilus lateralis*) which lacks the chipmunks' facial stripes. Only the cliff chipmunk (*Tamias dorsalis*) lives on the South Rim. On the North Rim are cliff chipmunks, Uinta chipmunks (*Tamias umbrinus*), and least chipmunks (*Tamias minimus*). The cliff chipmunk is the only one to venture into the Canyon as far down as the Tonto Platform.

Back in 1913, prior to national park sta-

tus and before the important ecological role of predators was understood, former president Theodore Roosevelt came to the Grand Canyon to hunt mountain lions (*Felis concolor*). This hunting episode became fictionalized in the children's classic *Brighty of the Grand Canyon*.

Desert bighorn sheep (*Ovis canadensis*) once roamed over much of the Southwest and were an important game animal for the native people. By the end of the nineteenth century, however, desert bighorns had been almost extirpated due to overhunting and diseases transmitted from domestic sheep. Bighorns in the Grand Canyon also had to compete with feral burros until the burros were removed in the 1970s. The burros were the descendants of animals released by early miners and residents.

Foxlike in appearance but house cat in size, the ringtail (*Bassariscus astutus*) is a relative of the raccoon. Ringtails usually live

near water and are highly efficient hunters of mice, squirrels, wood rats, and rabbits. They also eat carrion, birds, lizards, snakes, toads, insects, fruit, and nectar. They can rotate their hind feet almost 180 degrees like tree squirrels, giving them great traction as they descend a tree or cliff.

Five species of wood rats (*Neotoma* spp.) call the Grand Canyon home. Each species tends to occupy a particular ecological niche. They all build middens or houses of collected sticks, leaves, and any intriguing objects such as tin cans, spoons, scat, and stones. Deep within the midden is the nest made of finer material such as shredded bark. The bane of the camper in the Canyon are the various species of mice (*Peromyscus* spp.). Just when you are almost asleep, the pitter-patter of tiny feet can be heard near your food, in your backpack, or on your sleeping bag. Even biologist C. Hart Merriam in 1889 found them, "excessively abundant."

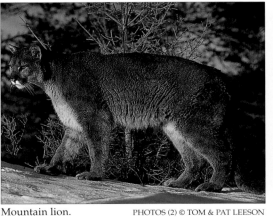
Mountain lion. PHOTOS (2) © TOM & PAT LEESON

Porcupine.

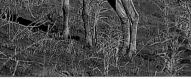
Desert bighorn sheep. PHOTO © MARY ALLEN

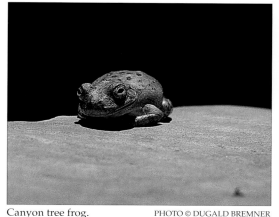

Canyon tree frog. PHOTO © DUGALD BREMNER

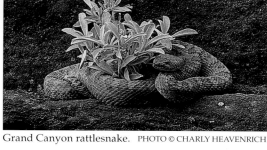

Grand Canyon rattlesnake. PHOTO © CHARLY HEAVENRICH

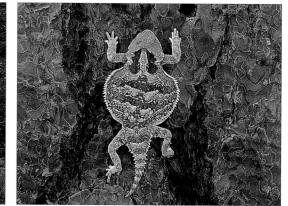

Short-horned lizard. PHOTO © STEWART AITCHISON

Thirty-five species of reptiles and a half dozen amphibian species call the Canyon home. Rarely seen, the shy, mild-mannered Grand Canyon rattlesnake (*Crotalus viridis abyssus*) is a sandy brown to salmon pink variety of the prairie rattler and is found only within the Canyon. This snake most frequently inhabits the desert scrub or riparian communities, but the first one described scientifically as a new subspecies was collected in 1929 on the Tanner Trail just 300 feet below the South Rim. They feed mainly on lizards, mice, and wood rats.

At first glance, the gopher snake (*Pituophis melanoleucus*) may be mistaken for a rattlesnake. When startled, it may flatten its head into a triangular shape, hiss loudly, and vibrate its tail, misleading people and possible predators that it is a poisonous snake. But gopher snakes neither have fangs nor poison; they are powerful constrictors that prey on rodents and the occasional bird.

The side-blotched lizard (*Uta stansburiana*), fence lizard (*Sceloporus undulatus*), and tree lizard (*Urosaurus ornatus*) are all small, quick reptiles common throughout the park and difficult for the casual observer to tell apart.

The distinctive mountain short-horned lizard (*Phrynosoma douglassi*), sometimes erroneously called a horny toad, is found on both rims but not within the Canyon where there seems to be plenty of appropriate habitat. Biologists are puzzled by this. When frightened, mountain short-horned lizards may squirt blood from the conjunctiva of their eyes, presumably to startle predators.

Northern whiptail lizards (*Cnemidophorus tigris*) are long thin reptiles that move in a curious, jerky, mechanical manner while searching rock crevices and digging in loose sand for food. They locate their prey, mostly beetles and flies, with a keen sense of smell.

One of the most handsome reptiles in the Canyon is the collared lizard (*Crotaphytus* spp.). Two kinds of collared lizards are found in the park, a brown-colored one and a yellow to blue-green type. Both occur in the desert scrub habitats within the Canyon, though the second type is sometimes observed along the South Rim, too. Whether they are two species or color variants of one is debated.

Amphibians, by their nature, need water. Some, like the spadefoot toad (*Scaphiopus* sp.), remain underground until the summer rains begin. In spite of its name, the diminutive canyon treefrog (*Hyla arenicolor*) is rarely in trees but usually on rocks near or in streams. Its loud, sheeplike bleating call belies its small size. The leopard frog (*Rana pipiens*) is only known from one marshy area along the Colorado River, but changes in the riparian zone brought by Glen Canyon Dam may create additional leopard frog habitat.

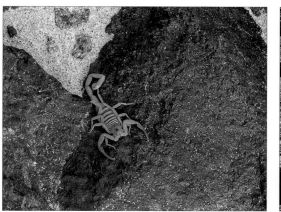

Scorpion. PHOTO © LARRY ULRICH

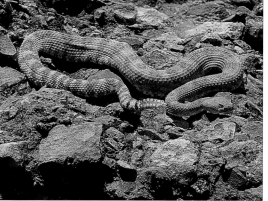

Speckled rattlesnake. PHOTO © LARRY LINDAHL

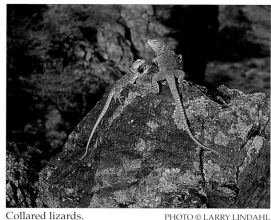

Collared lizards. PHOTO © LARRY LINDAHL

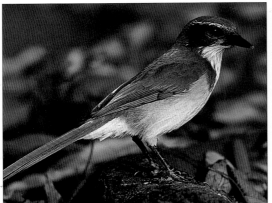

Scrub jay. PHOTO © TOM & PAT LEESON

Western tanager male. PHOTO © TOM & PAT LEESON

Stellers jay. PHOTO © TOM & PAT LEESON

More than 300 species of birds have been recorded in the Canyon area. In the high, cool boreal forests of the Kaibab Plateau, typical species include blue grouse, red-breasted nuthatches, dark-eyed juncos, warbling vireos, mountain bluebirds, and broad-tailed hummingbirds.

Upon descending into the ponderosa pine forest, pygmy and white-breasted nuthatches, mountain chickadees, and hairy woodpeckers become common. Although rare, the northern goshawk is a year-round resident and one of the main predators of Abert and Kaibab squirrels.

Ranging from forest to river, one of the most ubiquitous of the Canyon's birds is the common raven. These large, shiny black corvids soar and play on Canyon thermals and often scavenge where people have left food scraps behind. The raven's massive bill and wedge-shaped tail in flight help distinguish it from the smaller American crow, an irregular visitor at both rims.

In the same family as the raven, three species of jays may be observed along the rims. The Steller's jay with its crest is easy to identify. Scrub jays are of a plainer design and duller blue. The gregarious pinyon jays are overall pale blue and travel in large noisy flocks. They are colonial nesters and cache pinyon nuts by the thousands.

The haunting, high-pitched, descending trill of the canyon wren's song is the quintessential song of the Canyon country. Its relative, the rock wren, builds a nest out of sight under a ledge and constructs an entryway paved with small, flat stones.

The new ecosystem that has developed along the river since the completion of Glen Canyon Dam has provided habitat for certain insects, in turn leading to an increase in numbers of swifts and swallows. These birds are favored food for peregrine falcons, whose population has grown dramatically. On average a pair of peregrines nest every three miles along the Colorado in the Grand Canyon, the highest density of breeding peregrines outside Alaska. Additionally, this new population of peregrines has apparently replaced the formerly common American kestrel along the river.

During prehistoric times, the California condor must have been common based upon the number of bones found in Grand Canyon caves. The last definite historic record of condors near the Canyon was in 1881, although a sighting was reported near Williams about 1924. Beginning in 1996, condors have been released in the Vermilion Cliffs area and are now occasionally seen soaring over the Grand Canyon, where they may eventually nest.

Mountain bluebird male. PHOTO © TOM & PAT LEESON

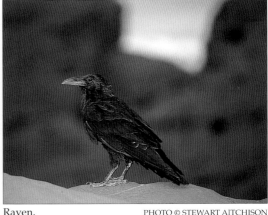

Peregrine falcon. PHOTO © TOM & PAT LEESON

Raven. PHOTO © STEWART AITCHISON

OPPOSITE: Great horned owl on a sandstone ledge. PHOTO © JEFF GNASS

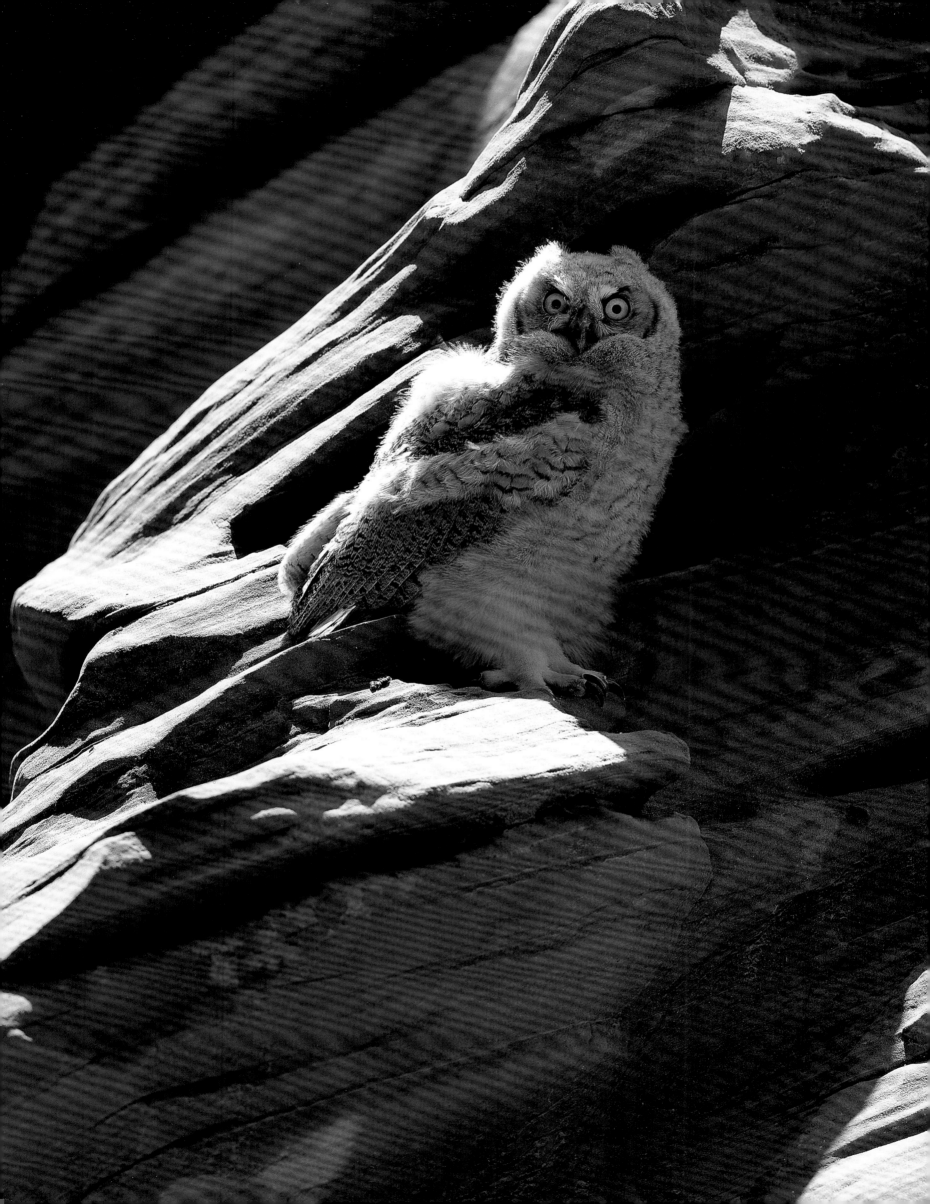

RESOURCES & INFORMATION

EMERGENCY & MEDICAL:
24-HOUR EMERGENCY MEDICAL SERVICE
Dial 911 (From hotel rooms dial 9-911)

GRAND CANYON CLINIC
(520) 638-2551

ROAD CONDITIONS:
GRAND CANYON	(520) 638-7888
ARIZONA	(520) 779-2711
COLORADO	(303) 639-1111
NEVADA	(702) 486-3116
NEW MEXICO	(800) 432-4269
UTAH	(801) 964-6000

FOR MORE INFORMATION:
NATIONAL PARKS ON THE INTERNET:
www.nps.gov

GRAND CANYON NATIONAL PARK
PO Box 129
Grand Canyon, AZ 86023-0129
(520) 638-7888
www.thecanyon.com/nps

ARIZONA STRIP INTERPRETIVE ASSOCIATION
345 E. Riverside Drive
St. George, UT 84790
(435) 688-3246
(435) 688-3258 (FAX)

GRAND CANYON ASSOCIATION
PO Box 399
Grand Canyon, AZ 86023
(520) 638-2481
(520) 638-2484 (Fax)
www.grandcanyon.org

GRAND CANYON FIELD INSTITUTE
PO Box 399
Grand Canyon, AZ 86023
(520) 638-2485
(520) 638-2484 (Fax)
www.thecanyon.com/fieldinstitute

GRAND CANYON TRUST
2601 N. Fort Valley Road
Flagstaff, AZ 86001
(520) 774-7488
(520) 774-7570 (FAX)
www.grandcanyontrust.org

KAIBAB NATIONAL FOREST
800 6th Street
Williams, AZ 86046
(520) 635-8200
www.fs.fed.us/r3/kai

MUSEUM OF NORTHERN ARIZONA
3101 N. Fort Valley Road
Flagstaff, AZ 86001
(520) 774-5211
(520) 779-1527 (FAX)
www.musnaz.org

PUBLIC LANDS INTERPRETIVE ASSOCIATION
Operates the Kaibab Plateau, and Williams Forest Service Visitor Centers.
6501 4th Street NW, Suite I
Albuquerque, NM 87107
(505) 345-9498
(505) 344-15432 (FAX)

LODGING INSIDE THE PARK:
AMFAC PARKS & RESORTS
14001 E. Iliff, Suite 600
Aurora, CO 80014
(303) 29 -PARKS
(303) 297-3175 (Fax)
www.amfac.com

GRAND CANYON NATIONAL PARK LODGES
PO Box 699
Grand Canyon, AZ 86023
(520) 638-2631
(520) 638-9247 (Fax)

CAMPING INSIDE THE PARK:
BIOSPHERICS
3 Commerce Drive
PO Box 1600
Cumberland, MD 21501
(800) 365-2267

LODGING OUTSIDE THE PARK:
FLAGSTAFF CHAMBER OF COMMERCE
101 West Route 66
Flagstaff, AZ 86001
(520) 774-4505

FLAGSTAFF VISITOR CENTER
1 East Route 66
Flagstaff, AZ 86001
(800) 842-7293
(520) 774-9541 (Fax)
www.flagstaff.az.us.com

GRAND CANYON CHAMBER OF COMMERCE
PO Box 3007
Highway 64 & 180
Grand Canyon, AZ 86023
(520) 638-2901
www.thecanyon.com/chamber

KANAB AREA CHAMBER OF COMMERCE
78 South 100 East
Kanab, UT 84741
(800) 733-5263
(435) 644-5033
www.kaneutah.com

PAGE/LAKE POWELL CHAMBER OF COMMERCE
& VISITOR INFORMATION
644 North Navajo, Suite C
PO Box 727
Page, AZ 86040
(888) 261-PAGE
(520) 645-2741
(520) 645-3181 (Fax)
e-mail: chamber@page-lakepowell.com

WILLIAMS-GRAND CANYON CHAMBER
OF COMMERCE
200 West Railroad Avenue
Williams, AZ 86046
(520) 635-1418
(520) 635-1417 (Fax)
www.thegrandcanyon.com

HORSE & MULE RIDES:
GRAND CANYON NATIONAL PARK LODGES
PO Box 699
Grand Canyon, AZ 86023
(520) 638-2631
(520) 638-9247 (Fax)

GRAND CANYON TRAIL RIDES
PO Box 128
Tropic, UT 84776
(435) 679-8665
www.onpages.com/canyonrides/

WHITEWATER RAFTING TRIPS:
NOTE: *The* **Backcountry Trip Planner** *has a complete list of whitewater rafting concessionaires operating within the park. To request a copy please contact:*
GRAND CANYON VISITOR CENTER
PO Box 129
Grand Canyon, AZ 86023
520-638-7771
www.thecanyon.com/nps

GRAND CANYON RAILWAY:
GRAND CANYON RAILWAY
1201 West Route 66, Suite 200
Flagstaff, AZ 86001
(800) THE-TRAIN (843-8724)
(520) 773-1610 (FAX)
www.thetrain.com

GRAND CANYON AIR TOURS:
AIR GRAND CANYON
PO Box 3399
Grand Canyon, AZ 86023
(800) 247-4726
(520) 638-2686
www.airgrandcanyon.com

AIR STAR HELICOPTERS, INC.
PO Box 3379
Grand Canyon, AZ 86023
(800) 962-3869
(520) 638-2139
(520) 683-2607 (Fax)
www.airstar.com

EAGLE SCENIC AIRLINES
275 E. Tropicana Avenue, Suite 220
Las Vegas, NV 89109
(800) 446-4584
(702) 736-3333
(702) 736-8431 (FAX)
www.eagleair.com

GRAND CANYON AIRLINES
PO Box 3038
Grand Canyon, AZ 86023
(520) 638-2407
(520) 638-9461 (Fax)
www.grandcanyonairlines.com

KENAI HELICOPTERS
PO Box 1429
Grand Canyon, AZ 86023
(800) 541-4537
(520) 638-2764
(520) 638-9588
www.flykenai.com

PAPILLON HELICOPTERS
PO Box 455, Highway 64
Grand Canyon, AZ 86023
(800) 528-2418
(520) 638-2419
(520) 638-3235 (Fax)
www.papillon.com

OTHER REGIONAL SITES:

BRYCE CANYON NATIONAL PARK
Bryce Canyon, UT 84717
(435) 834-5322

CEDAR BREAKS NATIONAL MONUMENT
PO Box 749
Cedar City, UT 84720
(435) 586-9451

GLEN CANYON NATIONAL RECREATION AREA
PO Box 1507
Page, AZ 86040
(520) 645-2471

HAVASUPAI INDIAN RESERVATION
Supai, AZ 86435
Campground: (520) 448-2121
Lodging: (520) 448-2111

HOPI INDIAN RESERVATION
Hopi Cultural Center
PO Box 67
Second Mesa, AZ 86043
(520) 734-2401

HUALAPAI INDIAN RESERVATION
Peach Springs, AZ
(520) 769-2419

KAIBAB PAIUTE INDIAN RESERVATION
Cultural Office
HC 65, Box 2
Fredonia, AZ 86022
(520) 643-7214

LAKE MEAD NATIONAL RECREATION AREA
601 Nevada Highway
Boulder City, NV 89005-2426
(702) 293-8907

MESA VERDE NATIONAL PARK
Mesa Verde National Park, CO 81330
(970) 529-4461

MONTEZUMA CASTLE NATIONAL MONUMENT
PO Box 219
Camp Verde, AZ 86322
(520) 567-3322

MONUMENT VALLEY NAVAJO TRIBAL PARK
PO Box 360289
Monument Valley, UT 84536
(435) 727-3353 or 727-3287

NAVAJO NATION
PO Box 9000
Window Rock, AZ 86515
(520) 871-6647

NAVAJO NATIONAL MONUMENT
HC 71, Box 3
Tonalea, AZ 86044-9704
(520) 672-2366 or 672-2367

PETRIFIED FOREST NATIONAL PARK
PO Box 217
Petrified Forest, AZ 86028
(520) 524-6228

PIPE SPRING NATIONAL MONUMENT
HC 65, Box 5
Fredonia, AZ 86022
(520) 643-7105

TUZIGOOT NATIONAL MONUMENT
PO Box 219
Camp Verde, AZ 86322
(520) 634-5564

WALNUT CANYON NATIONAL MONUMENT
2717 N. Steves Blvd., Suite 3
Flagstaff, AZ 86004
(520) 526-3367

WUPATKI & SUNSET CRATER VOLCANO
NATIONAL MONUMENTS
2717 N. Steves Blvd., Suite 3
Flagstaff, AZ 86004
(520) 556-7042

ZION NATIONAL PARK
Springdale, UT 84767
(435) 772-3256

SUGGESTED READING:

Abbey, Edward. *DESERT SOLITAIRE.* (1968). Reprint. New York, NY: Ballantine Books. 1971.

Aitchison, Stewart. *A WILDERNESS CALLED GRAND CANYON.* Stillwater, MN: Voyageur Press, Inc. 1991.

Aitchison, Stewart. *GRAND CANYON NATIONAL PARK: POCKET PORTFOLIO.* Mariposa, CA: Sierra Press. 1997.

Anderson, Michael F. *LIVING AT THE EDGE: EXPLORERS, EXPLOITERS AND SETTLERS OF THE GRAND CANYON REGION.* Grand Canyon, AZ: Grand Canyon Association. 1998.

Carothers, Steven W. & Brown, Bryan T. *THE COLORADO RIVER THROUGH GRAND CANYON.* Tucson, AZ: University of Arizona Press. 1991.

Collier, Michael. *WATER, EARTH, AND SKY: THE COLORADO RIVER BASIN.* Salt Lake City, UT: University of Utah Press. 1999.

Fletcher, Colin. *THE MAN WHO WALKED THROUGH TIME.* New York, NY: Alfred A. Knopf. 1967.

Grattan, Virginia L. *MARY COLTER: BUILDER UPON THE RED EARTH.* Grand Canyon, AZ: Grand Canyon Association. 1992.

Hall, Joseph G. *LINEA: PORTRAIT OF A KAIBAB SQUIRREL.* Grand Junction, CO: Joseph Hall. 1998.

Houk, Rose. *AN INTRODUCTION TO GRAND CANYON ECOLOGY.* Grand Canyon, AZ: Grand Canyon Association. 1996.

Lamb, Susan. *GRAND CANYON: THE VAULT OF HEAVEN.* Grand Canyon, AZ: Grand Canyon Association. 1995.

Leach, Nicky. *THE GUIDE TO THE NATIONAL PARKS OF THE SOUTHWEST.* Tucson, AZ: Southwest Parks & Monuments Association. 1992.

Powell, John Wesley. *THE EXPLORATION OF THE COLORADO RIVER AND ITS CANYONS.* (1895). Reprint. New York, NY: Dover Publications, Inc. 1961.

Price, L. Greer. *AN INTRODUCTION TO GRAND CANYON GEOLOGY.* Grand Canyon, AZ: Grand Canyon Association. 1999.

Reisner, Marc. *CADILLAC DESERT.* (1986). Reprint. New York, NY: Penguin Books. 1993

Schmidt, Jeremy. *GRAND CANYON: A NATURAL HISTORY GUIDE.* New York, NY: Houghton Mifflin Co. 1993.

Schwartz, Douglas W. *ON THE EDGE OF SPLENDOR: EXPLORING GRAND CANYON'S HUMAN PAST.* Santa Fe, NM: The School of American Research. n.d.

Stegner, Wallace. *BEYOND THE HUNDREDTH MERIDIAN.* New York, NY: Penguin Books. 1992.

Thybony, Scott. *OFFICIAL GUIDE TO HIKING THE GRAND CANYON.* Grand Canyon, AZ: Grand Canyon Association. 1997.

Wilson, Jim & Wilson, Lynn & Nicholas, Jeff. *GRAND CANYON: A VISUAL STUDY.* Mariposa, CA: Sierra Press. 1991.

Zwinger, Ann Haymond. *DOWNCANYON: A NATURALIST EXPLORES THE COLORADO RIVER THROUGH THE GRAND CANYON.* Tucson, AZ: University of Arizona Press. 1995.

ACKNOWLEDGMENTS:

I would like to extend a special "Thank You" to Pam Frazier, L. Greer Price, David Blacker, and all the excellent people at Grand Canyon Association; Ellis Richard, Chief of Interpretation, and his wonderful staff in the Grand Canyon's Interpretive Division; the friendly crew at the Grand Canyon Museum Collection; Stewart, Rose, and Darlece for producing such extraordinary materials in record time; to all the photographers who shared their personal visions of Grand Canyon with us during the editing of this title; and to the fine people at Sung In Printing, America for the beautiful printing job. To all, my profound and sincere thanks!—JDN

PRODUCTION CREDITS:

Author: Stewart Aitchison
Editor: Rose Houk
Book Design: Jeff D. Nicholas
Photo Editors: Jeff D. Nicholas and
 Laura M. Bucknall
Illustrations: Darlece Cleveland
Illustration Graphics: Laura M. Bucknall
Production Coordinator: Laura M. Bucknall
Printing Coordination: Sung In Printing
 America, Inc.

SIERRA PRESS

4988 Gold Leaf Drive
Mariposa, CA 95338
(800) 745-2631, (209) 966-5071, (209) 966-5073 (Fax)

e-mail: siepress@yosemite.net
Visit our Website at: www.nationalparksusa.com

OPPOSITE:

Winter sunrise from Yavapai Point, South Rim.
PHOTO © CARR CLIFTON

SIERRA PRESS

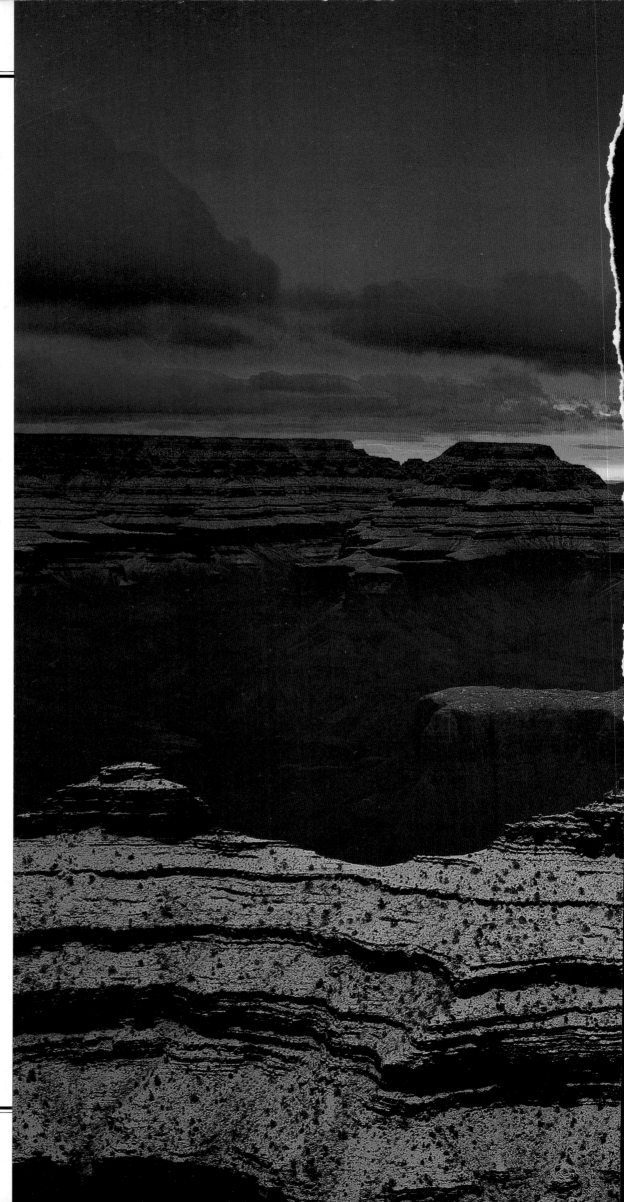